PIERO DELLA FRANCESCA

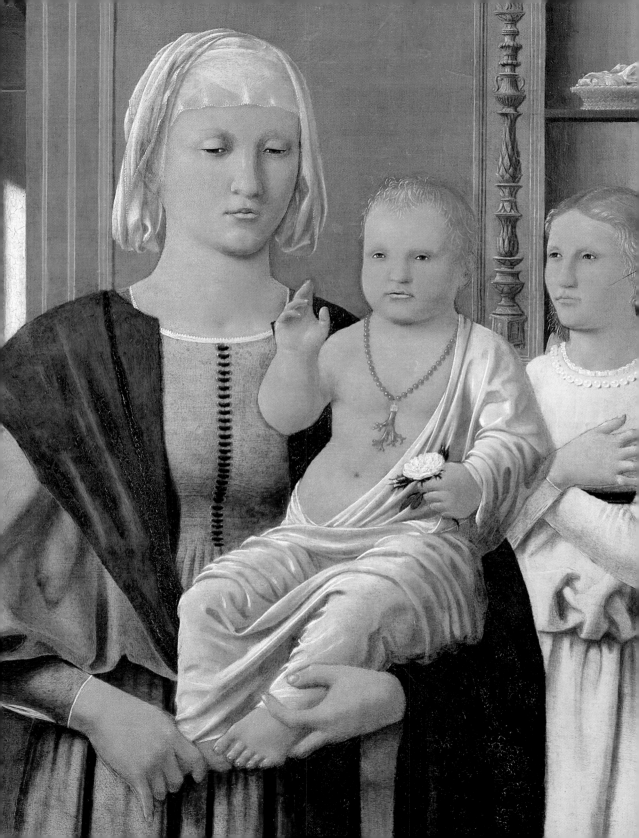

PIERO DELLA FRANCESCA
PERSONAL ENCOUNTERS

Keith Christiansen

with contributions by Roberto Bellucci, Cecilia Frosinini,
Anna Pizzati, and Chiara Rossi Scarzanella

The Metropolitan Museum of Art, New York

Distributed by Yale University Press, New Haven and London

This catalogue is published in conjunction with "Piero della Francesca: Personal Encounters," on view at The Metropolitan Museum of Art, New York, from January 14 through March 30, 2014.

The exhibition is made possible by the Foundation for Italian Art & Culture (FIAC). It was organized by The Metropolitan Museum of Art in collaboration with FIAC, in celebration of the opening of the New European Paintings Galleries, 1250 – 1800.

The loan of the Madonna di Senigallia is by arrangement with the Ministero dei Beni e delle Attività Culturali e del Turismo and the Italian Carabinieri Command (CCTPC) and is part of 2013 – Italian Year of Culture in the United States.

The catalogue is made possible by The Christian Humann Foundation. Additional support is provided by Jane Beasley, in memory of John P. O'Neill.

Published by The Metropolitan Museum of Art, New York
Mark Polizzotti, Publisher and Editor in Chief
Gwen Roginsky, Associate Publisher and General Manager of Publications
Peter Antony, Chief Production Manager
Michael Sittenfeld, Managing Editor
Robert Weisberg, Senior Project Manager

Edited by Barbara Cavaliere
Designed by Bruce Campbell
Production by Peter Antony and Paul Booth
Notes edited by Jayne Kuchna
Image acquisitions and permissions by Jane S. Tai and Ling Hu
Translations from the Italian by Frank Dabell

Typeset in Requiem
Printed on 100 lb. Creator Silk
Separations by Professional Graphics, Inc., Rockford, Illinois
Printed and bound by Puritan Capital, Hollis, New Hampshire

Jacket illustrations: front, detail of Saint Jerome and a Supplicant (cat. no. 3); back, detail of Madonna and Child with Two Angels (cat. no. 4)
Frontispiece: detail of Madonna and Child with Two Angels (cat. no. 4)
Chapter frontispieces: pp. 8 and 58, details of Saint Jerome and a Supplicant (cat. no. 3); p. 72, Saint Jerome and a Supplicant (cat. no. 3, before cleaning)

PHOTOGRAPH CREDITS

The Metropolitan Museum of Art endeavors to respect copyright in a manner consistent with its nonprofit educational mission. If you believe any material has been included in this publication improperly, please contact the Editorial Department.
Figs. 1, 17, 18, 23: Scala / Ministero per i Beni e le Attività Culturali / Art Resource, NY; fig. 2: © ALINARI – ARTOTHEK; fig. 3: © National Gallery, London / Art Resource, NY; figs. 4, 19, 26: Scala / Art Resource, NY; cat. no. 1, figs. 7, 8, 11, 39: Photographs by Juan Trujillo, The Photograph Studio, The Metropolitan Museum of Art; figs. 5, 28, 31, 32, 36, 38: Studio Fotografico Quattrone; figs. 6, 29: © RMN-Grand Palais / Art Resource, NY; fig. 12: Imaging Department © President and Fellows of Harvard College; fig. 13: Erich Lessing / Art Resource, NY; cat. no. 2, figs. 30, 37: BPK, Berlin / Gemäldegalerie, Staatliche Museen / Joerg P. Anders / Art Resource, NY; cat. no. 3: Courtesy Opificio delle Pietre Dure; fig. 33: www.laboratorioroma.it; cat. no. 4: Photograph by Angelo Rubino; pp. 72, 74, 76, 77, 78: Photography by Archivio Opificio delle Pietre Dure, Firenze

The Metropolitan Museum of Art
1000 Fifth Avenue
New York, New York 10028
metmuseum.org

Distributed by
Yale University Press, New Haven and London
yalebooks.com/art
yalebooks.co.uk

Cataloging-in-Publication Data is available from the Library of Congress.
ISBN 978-1-58839-529-0 (The Metropolitan Museum of Art)
ISBN 978-0-300-19946-8 (Yale University Press)

Contents

Sponsor's Statement

FIAC is delighted and honored to sponsor "Piero della Francesca: Personal Encounters," a special exhibition in celebration of the New European Paintings Galleries, 1250–1800, at The Metropolitan Museum of Art.

What began as a conversation about a single loan exhibition from Venice has grown into a fascinating study of four paintings, offering an intimate and unique experience of the devotional paintings of the great master from Sansepolcro, Piero della Francesca. We are so pleased to contribute to this thoughtfully considered exhibition, as it epitomizes FIAC's mission: to illuminate and promote exceptional Italian Art in the United States. This occasion marks the second opportunity FIAC has had to work with the Met, the first being the equally focused and no less ambitious exhibition of "Antonello da Messina: Sicily's Renaissance Master" in 2005.

Along with our distinguished Board Members, we wish to express our sincerest thanks to our colleagues in Italy who have played a crucial role in organizing this exciting event:

Dott.ssa Giovanna Damiani, Superintendent of Venice, Dott.ssa Rosaria Valazzi, Superintendent of Urbino, Dott. Matteo Ceriana, Director, Gallerie dell'Accademia, Venice, and the Italian Carabinieri Command. A special debt of gratitude is due to Dott. Marco Ciatti and his staff at the Opificio delle Pietre Dure in Florence, where they assumed the cleaning and technical examination of the Venice painting. Further thanks are due to Dr. Bernd W. Lindemann, Director, Gemäldegalerie and Skulpturensammlung und Museum für Byzantinische Kunst, Berlin. We extend our deep appreciation to Dr. Thomas P. Campbell, Director of the Metropolitan Museum and to Keith Christiansen, John Pope-Hennessy Chairman of the Department of European Paintings, for their ongoing and invaluable guidance to FIAC.

We are certain that this historic and noteworthy exhibition will prove a great success.

 Daniele Bodini, *Chairman*
Alain Elkann, *President*

Director's Foreword

The Metropolitan Museum of Art is delighted to present *Piero della Francesca: Personal Encounters.* This book — an appropriately small gem — has been published in conjunction with an exhibition at the Met around one of the jewels in the collection of the Gallerie dell'Accademia in Venice: Piero della Francesca's Saint Jerome and a Supplicant. This is the first time the panel has traveled outside Italy.

The exhibition and publication are the result of a rare convergence of events. Giovanna Damiani, Superintendent in Venice, and Matteo Ceriana, director of the Gallerie dell'Accademia, invited the Met to collaborate on a project involving the technical examination and cleaning of the Saint Jerome painting. Concurrently, Daniele Bodini and Alain Elkann proposed that the Foundation for Italian Art and Culture sponsor an event comparable in importance to the 2005 Met exhibition "Antonello da Messina: Sicily's Renaissance Master," for which they were responsible. The Met was pleased to embrace the project, and Keith Christiansen, John Pope-Hennessy Chairman of the Museum's Department of European Paintings, worked in close collaboration with colleagues in Italy and Germany to make it a reality. Taking the Accademia painting as a starting point, he expanded the initial idea to create the first study devoted to Piero della Francesca's devotional paintings.

These magical pictures trace Piero's development as a painter of devotional images from his earliest work, made in Florence about 1439–40, to one of his latest, the solemn Madonna and Child with Two Angels painted for Federico da Montefeltro's court at Urbino — a loan made possible, in recognition of the Year of Italian Culture, by the Ministero dei Beni e delle Attività Culturali e del Turismo and the work of the Italian Carabinieri Command. Although modest in scale, together the works testify to Piero's consummate power of invention and to his masterful combination of intimacy and gravity that both invites the viewer and inspires a sacral awe.

We are grateful for the visionary support provided by the Foundation for Italian Art and Culture for making this project possible. This book was brought to fruition through the generosity of The Christian Humann Foundation, and by Jane Beasley in memory of John P. O'Neill, Publisher and Editor in Chief at the Metropolitan for over thirty years, whose passion and knowledge of Renaissance art and architecture informed so many of the Museum's publications.

Thomas P. Campbell
Director
The Metropolitan Museum of Art

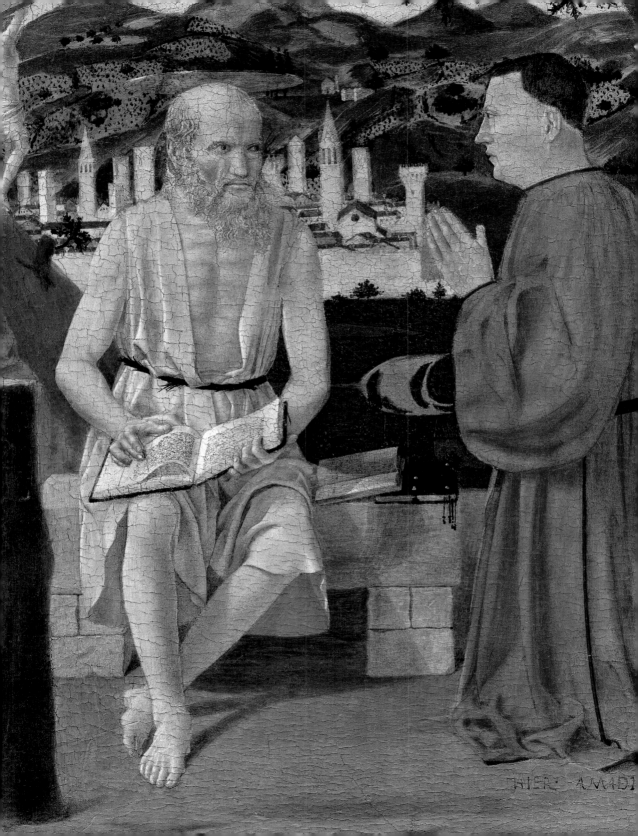

PIERO DELLA FRANCESCA
PERSONAL ENCOUNTERS

BY KEITH CHRISTIANSEN

Mention the name Piero della Francesca and the image that likely comes to mind is a scene from his celebrated fresco cycle in the church of San Francesco, Arezzo, depicting the legend of the Holy Cross—perhaps the haunting Dream of Constantine (figure 1), with the acutely foreshortened angel slicing through the darkness of night and bathing with its silvery radiance the figure of the sleeping commander beneath his tent and the three men guarding him. For lovers of Renaissance art, a pilgrimage to Arezzo is obligatory, together with one to Piero's hometown of Borgo Sansepolcro to see on a wall of the Council Chamber of the former town hall, now a museum, the Resurrected Christ (see figure 19)—the fresco that, in an essay of 1925, Aldous Huxley christened, quite simply, "the best picture in the world."[1] It is one of those images that has entered our collective imagination—that broad-shouldered columnar figure with features as plain as a peasant, who has about him an air of serene inevitability. He plants his foot firmly on the edge of the sarcophagus in his triumph over death, while the sleep of exhaustion lies heavily on the Roman soldiers posed in studied disarray around his tomb. Ideally, our pilgrim will have stopped en route at the little town of Monterchi to take in the pregnant

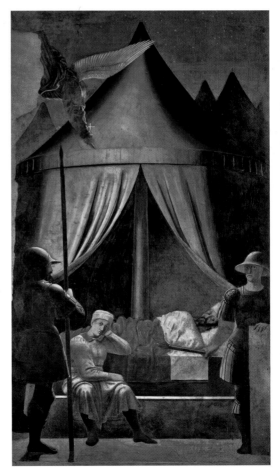

Figure 1. Piero della Francesca, The Legend of the Holy Cross, Constantine's Dream, ca. 1452–58. Fresco, 128½ × 74¾ in. (329 × 190 cm). San Francesco, Arezzo

9

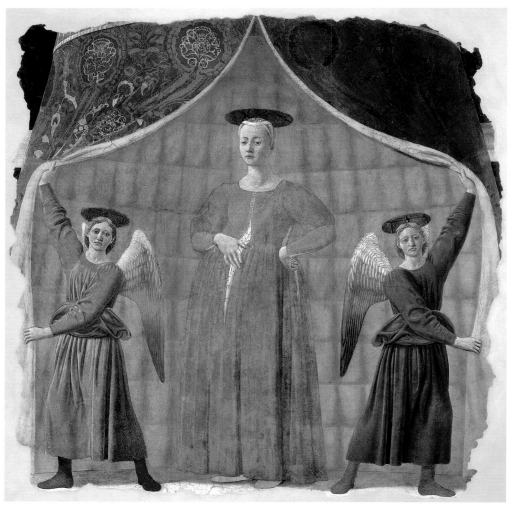

Figure 2. Piero della Francesca, Madonna del Parto, ca. 1455–60? Detached fresco, 102⅜ × 80 in. (260 × 203.2 cm). Museo della Madonna del Parto, Monterchi

Madonna del Parto (figure 2). She stands austerely, like a sacred idol, beneath a tent-like pavilion with ermine-lined brocaded sides held open by two heraldically posed angels, one rose-winged, clothed in pale green with red boots, the other green-winged, wearing an aubergine-colored robe with pale-green boots (the angels were generated from the same preparatory cartoon that has been flipped, and the varied distribution of the colors relieves what otherwise would be an almost primitive symmetry). What with her pensive gaze, the perfect oval of her head emphasized by her high forehead and pulled-back hair that is held in place with bands of white cloth, and the meaningful gesture of her right hand placed ceremoniously on her

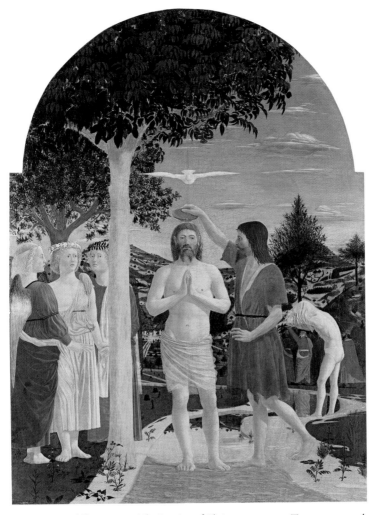

Figure 3. Piero della Francesca, The Baptism of Christ, ca. 1445–50. Tempera on panel, 66 × 46 in. (168 × 116 cm). National Gallery, London

swollen womb, which presses against the lacing of the bodice of her dress — a plain woolen garment known as a *gamurra da parto* (a pregnancy gown) — she is one of Piero's most haunting creations. Yet one may wonder what solace this proud figure provided to prospective mothers facing the dangers of childbirth who knelt before her, appealing for her protection.

Tenderness is not an adjective that comes to mind with Piero.[2]

If our pilgrim is assiduous in following what has become known as the Piero Trail,[3] he or she will not end the journey in Sansepolcro but will press on, following the tortuous road that takes one by way of the Bocca Trabaria over the Appenines and into a verdant Metauro valley

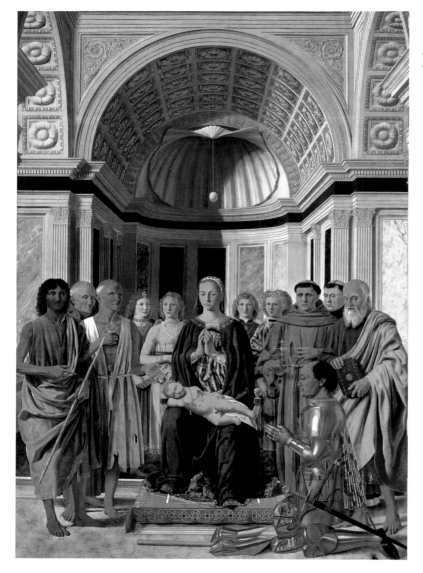

Figure 4. Piero della Francesca,
Madonna and Child with Saints
(Montefeltro Altarpiece),
ca. 1464–66? Oil and tempera
on panel, 97⅝ × 66⅞ in. (248 ×
170 cm). Pinacoteca di Brera,
Milan

before making the steep climb to Urbino. There, the objective will be a small painting in the Ducal Palace showing the Flagellation of Christ (see figure 18). In it, the conventional narrative hierarchies of Renaissance painting have been reversed, and the foreground is occupied not by the ostensible subject of the picture but by three enigmatic figures: a portrait of a contemporary patrician wearing a luxurious blue and gold brocade robe; a bearded figure in courtly Byzantine dress, his gaze directed toward some undefined point, his left hand raised in response to an unheard assertion; and one of those archetypal figures Piero so loved, simply garbed, barefoot,

left arm akimbo, evidently intended to represent someone from the distant past or perhaps the sacred realm (there is a resemblance to Piero's angels). The silent and apparently dispassionate discussion among this triad and its relation to Christ's Flagellation, to which our sight is drawn by the perspective construction no less than by the light that plays on the ceiling of the pretorium, has captivated countless viewers and provided rich fodder for scholarly speculation. According to one nineteenth-century account, a now-lost frame bore a Latin inscription from the Psalms (2:2): "Convenerunt in unum" ("The kings of the earth set themselves, and the rulers take counsel together, against the Lord and against his anointed"). The verse describes the activity of the three mysterious figures without satisfactorily resolving the enigmatic character of the picture, which has to do with more than a coded subtext. Its poetry is one of incongruities.

Together with the pair of double-sided portraits in the Uffizi depicting Federico da Montefeltro and his wife Battista Sforza (figure 31), the Flagellation is the only one of Piero's small-scale pictures to have gained the kind of celebrity enjoyed by his large-scale frescoes and altarpieces, such as the Baptism of Christ (figure 3) in the National Gallery, London, or the great altarpiece created for Federico da Montefeltro in the Pinacoteca di Brera, Milan (figure 4). And yet, in addition to his public altarpieces, Piero also, on occasion and for special patrons, painted works for private devotion. Only four of these survive, or rather four that are certainly by him and a fifth that probably is. The Flagellation is one of these, though it is difficult to understand how exactly it served the primary purpose of a devotional painting, the function of which is to inspire meditation rather than provoke abstruse discussion. The others are the subject of this publication, and they introduce an aspect of Piero's art that, strangely enough, has not received the attention it deserves. Their subjects are among the most common in the fifteenth century, and this, perhaps, is one of the reasons for the lack of attention, since so much scholarship on the artist relates to problems of iconography. Two show the Madonna and Child, and two Saint Jerome in the Wilderness. The very rarity with which Piero undertook such private commissions testifies to their exceptional status, for Piero never lacked work and was not one of those artists who developed a large workshop for the production of serial devotional images, as, for example, Sandro Botticelli and Giovanni Bellini did.[4] The four pictures that concern us include what is probably Piero's earliest surviving picture, and one usually considered among his last. Each testifies to a different aspect of his art; each poses specific problems; and each requires individual consideration.

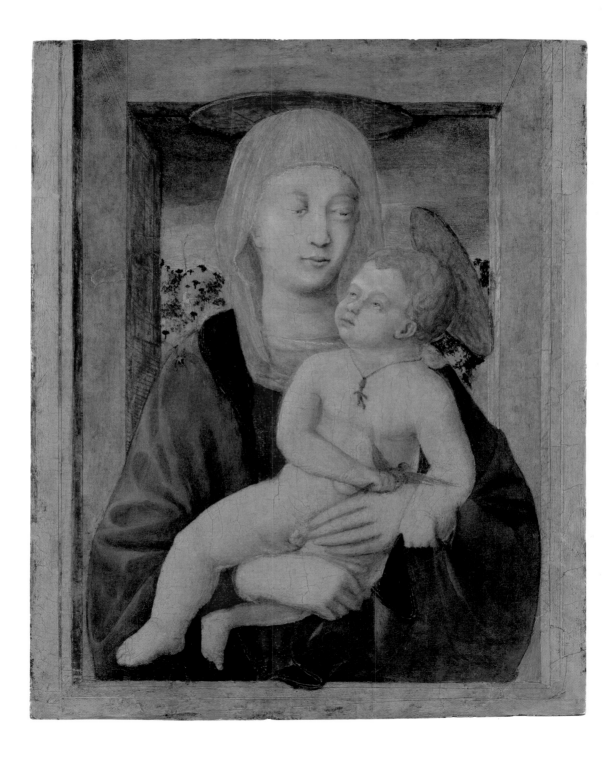

1. Madonna and Child

Ca. 1439–40. Tempera on panel, 20⅞ × 15¾ in. (53 × 40 cm)
Alana Collection, Delaware

"This is without doubt the earliest work of the master's that has come down to us; before the Baptism of Christ and the first portions of the polyptych [of the Madonna of Mercy] in Sansepolcro; thus around [14]40, when Piero worked with Domenico Veneziano [in Florence]."[5] Only Roberto Longhi — the outstanding Italian connoisseur and scholar whose 1927 book on Piero della Francesca remains a classic for its descriptive writing and critical probity — could have brought into play so audaciously and succinctly this worn yet intriguing painting, which previously had been unknown to the literature on Piero. At the time — the attribution was made in the second edition of his monograph, in 1942 — little enough was known about Piero's beginnings. The date of his birth was estimated to have been between 1410 and 1420, and practically nothing was certain concerning his activity prior to his documented appearance in Florence in September 1439, at the side of Domenico Veneziano, working on a splendid but now-lost cycle of frescoes. Although today we know a good deal more about Piero's early activity as an artist, Longhi's evaluation still seems correct.[6]

Piero was probably born in 1412, the oldest of eight children, six of whom survived into adulthood — four boys and two girls. His father was a well-to-do citizen in Sansepolcro, a dealer in leather goods who became involved with his wife's brothers in the more prestigious and financially important wool trade. Like their father, Piero's younger brothers Marco and Antonio became merchants (it was Marco who, after their father's death, seems to have handled most of the family's financial transactions). However, the oldest of Piero's brothers, Francesco, became a Camaldolese monk, so Piero was not the only member to strike out on his own path, which he evidently did with the support of his father, who stood as witness to various contracts and payments. In a town like Sansepolcro, family connections counted for much, and they certainly helped shape Piero's early career. His family was closely associated with a lay confraternity of flagellants, Santa Maria della Misericordia, which had benefited from a legacy of his uncle's and for which his brother Francesco served for a brief period as chaplain (*cappellano*). It was this confraternity that, in 1445, commissioned an altarpiece from Piero, which, in a fashion that was to typify his work for his hometown, he took over fifteen years to complete. His mother's family was from Monterchi, and a kinsman had been a priest in the church where he painted the fresco of the Madonna del Parto.[7] Piero's brother Marco married well, and it may have been through Marco's wife's kinsman Jacopo degli Anastagi that Piero came to work in 1451 for Sigismondo Malatesta, the celebrated *condottiere* and ruler of Rimini (Jacopo was Sigismondo's secretary and ambassador until he fell into disgrace in 1464–65). Piero's family's

commercial interests in cloth and woad—an important source of blue dye for the textile trade (witness the luxurious blue brocade worn by the bystander in Piero's Flagellation; figure 18)—established a network of links within Sansepolcro as well as with Florence.[8] The Della Francesca owned a residence bordering on property of two of the most prominent families in Sansepolcro, the Pichi and the Graziani, both of whom were key patrons.[9] His family's status assured Piero a good education, possibly at a grammar school where he would have learned elementary Latin and at a school where commercial mathematics and accounting were taught together with some geometry—a *scuola d'abaco*.[10] Mathematics and geometry were to become a lifelong obsession of Piero's, eventually supplanting his practice as a painter. In addition to his textbook on mathematics, the *Trattato d'abaco*, he wrote a treatise on perspective, the *De prospetiva pingendi*, and an ambitious exposition of Euclidean geometry, the *Libellus de quinque corporibus regularibus*, which was composed in Italian, translated into Latin, and dedicated to Duke Guidobaldo da Montefeltro, the ruler of Urbino, whose deceased father had employed Piero and for whom the artist retained a deep esteem.[11]

Sansepolcro, which had an estimated population of 4,000 to 4,500 in the fifteenth century, was a fairly important regional commercial center because of its position on the trade routes extending from Florence across the Apennines to the Adriatic coast. But there is no question that it was something of a cultural backwater, and Piero's apprenticeship was with a late Gothic artist from the nearby town of Anghiari, Antonio di Giovanni, who in the 1430s took up an extended residency in Sansepolcro. Antonio's talents would not have taken him far in Florence, but in Sansepolcro, he became the leading figure, and Piero collaborated with him, invariably in a subordinate and sometimes even menial way, on a number of projects.[12] The example Antonio provided was that of a can-do artisan, and his notion of painting was of a worthy craft rather than an intellectual endeavor. It seems remarkable that it took someone of Piero's intellect and ambition so long to break free, travel to Florence, and make contact with artists of the first rank.[13] For whatever reason, after January 1438, Antonio d'Anghiari was a sporadic presence in Borgo; he moved to Arezzo, where in 1447 he applied for citizenship. Piero is documented in Sansepolcro in May 1438, and then he too made the move that would transform him from a provincial painter of regional importance to one of the great figures of Renaissance painting.

The catalyst for this transformation came in 1438–39, when, again in a subordinate position, he found a place at the side of one of the truly great figures of Renaissance painting, Domenico Veneziano. On September 12, 1439, Piero was paid two florins and fifteen soldi, and he is listed as working with Domenico—"*sta collui assieme.*" Had he conceivably already established contact with Domenico during the latter's work for the Baglione family in Perugia, just fifty kilometers south of Sansepolcro, in 1437–38? Whatever the case, the world that opened before him in Florence required a complete rethinking of the premises and possibilities of painting.[14] The great works of the previous decade—especially Masaccio's frescoes in the Brancacci Chapel—were to leave a lasting imprint on his imagination, although it is not until Piero's works of the 1450s and 1460s that we see the full impact of Masaccio's grand and grave manner. Like any young visitor, his first reaction was to the whirl of contemporary activity in one of the great

metropolises of Europe. In January, Pope Eugenius IV had moved from Ferrara to Florence the Church Council that sought to resolve the divisions between the Greek and Latin churches. The transfer added luster to the city, created commercial opportunities, and brought a contingent of Greek scholars, giving a boost to those Humanist studies promoted by Cosimo de' Medici. The richly attired Greeks, with their elaborate hats and gold-threaded damasks, left an enduring impression on contemporaries—on no one more than Piero, who populated his subsequent work with figures in Byzantine dress. Among the more than one hundred papal abbreviators who accompanied Eugenius to Florence was Leon Battista Alberti, the author of a groundbreaking treatise on painting, the Italian translation of which he dedicated in 1436 to Filippo Brunelleschi. The *De pictura* was to provide the theoretical backbone for Renaissance art, and together with his later treatise on architecture—the *De re aedificatoria* (the first draft was completed about 1450)—it established Alberti as its leading intellectual authority. Alberti and Piero had much in common. Both were to work for some of the same princes, and if they did not meet in Florence in 1439–40, their paths almost certainly crossed later in Ferrara, Rome, and Urbino. When Eugenius IV consecrated the cathedral on March 25, 1436—the feast day of the Annunciation and the first day of the Florentine new year—Brunelleschi's dome, "vast enough to cover the entire Tuscan population with its shadow, and done without the aid of beams or elaborate wooden supports,"[15] still lacked its lantern. However, the choir lofts (*cantorie*), with their innovative sculpture by Luca della Robbia and Donatello, were in place, and the first perspective panels in intarsia were being installed in the north sacristy, the *Sacrestia delle*

messe (figure 5). Lorenzo Ghiberti was busy with the doors for the Florentine baptistery that would become models of composition for a generation, while Fra Angelico was at work in the Medicean convent of San Marco, where he had already completed part of his celebrated fresco decoration and for which he had been contracted to paint the high altarpiece, a defining work of the new style. Fra Filippo Lippi was well advanced on a no-less innovative altarpiece for the sacristy of the church of Santo Spirito and had other, equally impressive commissions in hand. Paolo Uccello was bringing to completion his great series of paintings showing episodes of the Battle of San Romano for Lionardo Bartolini Salimbeni.[16] Domenico Veneziano too had managed to secure a foothold for himself in this busy environment with the commission from the Portinari family for a fresco cycle depicting scenes from the life of the Virgin in the church of San Egidio. All that survives today of the cycle, which he left unfinished, are decorative fragments, together with the preparatory *sinopia* for the perspectival pavement for one scene.

It is at this point in Piero's career—in 1439, in Florence, where the painter from Sansepolcro cast his curious eyes about and engaged his subtle intellect—that the Madonna and Child first published by Longhi in 1942 finds its place. Of its early history, we can only say with certainty that it was held in some regard in Florence in the seventeenth century, when according to an inscription boldly scrawled on the reverse side, the painter Alessandro Rosi (1627–1697) undertook a restoration ("*ritoccata*" is the word used by Rosi, who had a secondary occupation restoring paintings).[17] Whether it was he or a later restorer who virtually stripped off any surface refinement cannot be said, but the picture Longhi published

Figure 5. Antonio Manetti, 1436–45. Detail of intarsia from the north wall of the north sacristy of Florence Cathedral

had been heavily repainted. Indeed, only since its careful cleaning and discreet inpainting of losses undertaken in 2005 can the picture be read with confidence.[18]

In 1685, the picture was optimistically and somewhat anachronistically ascribed to Leonardo da Vinci, and it was with considerable pride and chutzpah that Rosi scrawled his "contribution" to the picture's altered appearance on an unpainted margin on the reverse side. The basis for the attribution to Leonardo must have been the perspective construction of the images that appear on the front and especially on the back of the panel. On the principal side, the Madonna and Child stand behind a window casement and in front of another, with the shutters open to a landscape view, while on the reverse side, a large vase or wine cooler (*renfrescatoio*) is placed on a shelf or ledge between two casement moldings. Although similar in the interest they show for an illusionistic perspectival setting, the two images clearly were not intended as related, for while the Madonna and Child is a vertical composition, the wine cooler is a horizontal one, with broad unpainted margins (see figure 7). It seems likely, therefore, that the artist—who, it is assumed here for the sake of argument, can hardly be anyone other than Piero—first used the reverse side of the panel for an elaborate exercise in perspective and then painted its primary side with a work for private devotion. This analysis is borne out by the fact that prior to painting the wine cooler on the reverse side of the panel, which was salvaged from a piece of furniture, a rectangular cavity measuring 6 by 5¾ by ¾ inches (15.3 × 13.2 × 1.8 cm) had to be

filled.[19] This was done in a rather makeshift manner by embedding three pieces of wood of unequal size into the cavity. The surface was then gessoed, and the scheme for the wine cooler was laid in with a meticulous series of incisions and pinpricks, indicating that previously, the composition had been carefully worked out in detail on paper, and the results were then laboriously transferred to the panel. It's a process familiar from the elaborate perspective drawings of objects — a chalice or the form for a hat (*mazzocchio*) — usually ascribed to Uccello and dated to the 1430s (figure 6).[20] The method involved was not unique, but significantly, it is one Piero later elaborated upon at length in his treatise on perspective, *De prospetiva pingendi,* in which, in point of fact, he gives as one of his exercises, or problems, the depiction of a footed wine cooler — *"uno renfrescatoio col piedistallo"* — which should appear on a table or [other] surface. "And if you wish it to be faceted," he writes, following minute instructions for rendering the object in perspective, "divide the form of the wine-cooler in as many facets as you like, establishing the width of the wine-cooler and follow the method [I have already] given."[21] Curiously, the perspective rendition of this trompe-l'oeil intarsia — for that is what it is — has been described in the literature as empirical, whereas much to the contrary, it has been carefully measured out and plotted in exactly the manner that Piero's instructions imply.[22]

The vanishing point has been indicated by a pinprick located on the vertical axis, which is inscribed from the top of the composition to the bottom, and along a horizontal slightly above the midway point, indicated by pinpricks and not by an incision (figure 8). The depth of the shelf in which the wine cooler is placed has been determined by incising diagonal lines (orthogonals) from the vanishing point and then horizontal lines (transversals). The resulting foreshortened squares are indicated at the two extremities of the shelf (figure 9). Regardless of whether Piero was interested in depicting a foreshortened human head or a wine cooler,

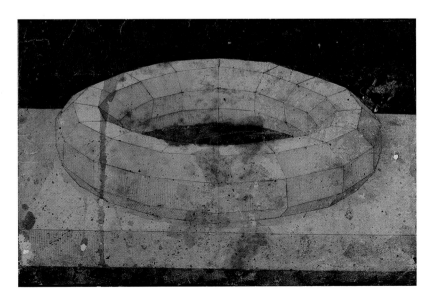

Figure 6. Attributed to Paolo Uccello, perspective view of a *mazzocchio,* recto (Fonds des dessins et miniatures), ca. 1449 – 50. Pen and brown ink, 6⅛ × 9¼ in. (15.6 × 23.5 cm). Musée du Louvre, Paris

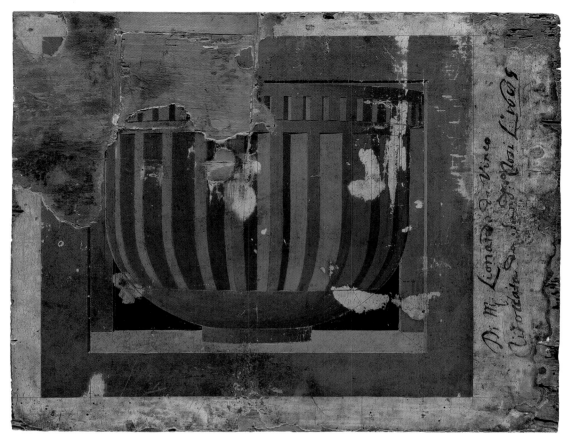

Figure 7. Reverse of the Madonna and Child (cat. no. 1) showing a fictive intarsia of a wine cooler on a shelf viewed in perspective. On the unpainted area is an inscription recording the name of the seventeenth-century Florentine painter who restored it

Figure 8. Diagram showing the perspectival system of the wine cooler in figure 7

he insisted on mathematical exactitude. He achieved this through a painstaking process of making measured cross sections of the object at crucial intervals, combining these coordinates with those taken from a drawing of the object seen from the front and side and then combining the results on the flat surface on which the object was to be shown in perspective or foreshortening. It was a process equivalent to that of

Figure 9. Detail showing the incised lines in the lower right that define the depth of the shelf or niche in figure 7

an architectural drawing combining floor plan and elevation. In the case of the wine cooler, three cross sections were made, and these are indicated by the horizontal line scored through the lower half of the wine cooler, the pinpricks at the midway point, and another series of pinpricks along the upper edge of the casement. The spacing of the pinpricks along the upper edge determined the diminishing size of the dentilled molding that runs around the top of the cooler. Further series of pinpricks map out the ridges of the facets and the triangular areas of the channels (figure 10). Though at first glance the foot of the wine cooler might appear to have been foreshortened empirically, in fact it has been methodically and meticulously mapped out by twelve pinpricks spaced at graduated distances from each other. It's a case of mathematical measurement trumping the subjective judgment of the eye. The stereometry of the wine cooler has been emphasized by

Figure 10. Detail showing the complex system of pinpricks and incised lines that enabled the design to be transferred from a cartoon on which the perspective of the wine cooler in figure 7 was carefully worked out

gradating the color of each constituent part in precisely the same fashion found in the practice of wood inlay, or intarsia.

There can be little doubt that inspiration for this perspectival demonstration was provided by the work in the *Sacrestia delle messe* in the cathedral of Florence, for which designs had been submitted by Antonio Manetti and Agnolo di Lazzaro beginning in 1436.[23] Piero, it seems, was fascinated by this innovative enterprise, which involved mathematics and artistry in a totally new and novel way. We know that he continued to be interested in intarsia and established a close relationship with the woodworkers Cristoforo and Lorenzo da Lendinara in Ferrara during their employment on Leonello d'Este's celebrated *studiolo* between 1449 and 1453 (like Piero, Lorenzo wrote a treatise on perspective, which, however, has not survived).[24]

On the principal side of the panel, Piero adapted the ideas implicit in the illusionism of the wine cooler for a devotional representation of the Madonna and Child viewed behind a parapet or through a window casement. Here again, Piero was taking up ideas circulating among the principal painters of Florence in the years around 1440. The analogy with Fra Filippo Lippi's portrait of a woman and man in the Metropolitan Museum (figure 11), in which the female figure stands before a window open to a landscape view, has been cited by more than one scholar,[25] but a no-less pertinent comparison is offered by his badly damaged Madonna and Child in the Utah Museum of Fine Arts, in which the figures are shown behind an elaborate parapet and in front of a niche. Paolo Uccello's extraordinary Madonna and Child in the National Gallery of Ireland, Dublin, provides another example, though perhaps the most intriguing analogies are with a Madonna and

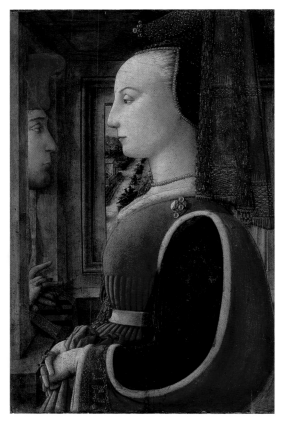

Figure 11. Fra Filippo Lippi, Portrait of a Woman with a Man at a Casement, ca. 1440. Tempera on wood, $25\frac{1}{4} \times 16\frac{1}{2}$ in. (64.1 × 41.9 cm). The Metropolitan Museum of Art, Marquand Collection, Gift of Henry G. Marquand, 1889 (89.15.19)

Child by Filippo Lippi's pupil Giovanni di Francesco in the Harvard Art Museums (figure 12)[26] and a painting by the younger brother of Masaccio, Giovanni di Ser Giovanni, called Scheggia, in the Museo Horne in Florence.[27] Scheggia's painting is of particular interest insofar as he produced cartoons for the *Sacrestia delle messe*.

Piero's scheme differs from the Florentine images cited above in its geometric clarity. As with the pseudo-intarsia rendition of a wine

cooler, the window casements have been projected from a single vanishing point, here located just above the wrist of the Virgin's right hand. Both the enframing window casement, with its outer and inner moldings, and the plain window opening at the back of the Virgin's chamber are foreshortened to this vanishing point, with transversals incised toward the bottom corners. Unfortunately, because the composition has been cut at the top, it is not possible to say what kind of molding Piero intended to crown the window at which the Virgin appears. But it is quite clear that the chief motif of the design was the appearance of the sacred figures at a window opening, with a fold of the Virgin's cloak resting on the bottom ledge, establishing at once an intimacy with the viewer/worshiper and a decorous separation. The casement is realized in the shades of pink we have come to associate with Domenico Veneziano, and the haloes of the two figures are depicted as discs with edges—as is found in Veneziano's Madonna and Child in Bucharest and also in his detached fresco of the Madonna and Child Enthroned in the National Gallery, London, both usually dated to the mid- to late 1430s, as well as in Uccello's Madonna and Child in Dublin. Each of these motifs thus aligns the picture formerly in the Contini Bonacossi Collection, Florence, with the trajectory of Florentine painting in the years between about 1435 and 1440. But one peculiarity of the illusionistic frame also announces a device Piero was to favor throughout his career. In his votive fresco in the Tempio Malatestiano in Rimini (figure 13) showing Sigismondo Malatesta kneeling before his patron saint, the audience hall, with its inlaid marble pavement and its back wall with pilasters supporting an elegant entablature, is viewed through a feigned classical molding. Piero ingeniously overlapped

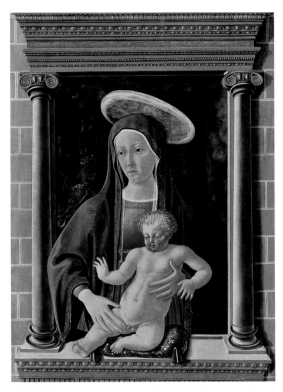

Figure 12. Master of Pratovecchio (Giovanni di Francesco?), The Virgin and Child, ca. 1450–75. Tempera on panel, 31 × 25⅝ in. (78.7 × 65.1 cm). Harvard Art Museums/Fogg Museum, Department of Paintings, Sculpture & Decorative Arts, Gift of Mr. and Mrs. Arthur Lehman (1927.66)

this with the interior entablature so that the carefully projected space of the hall indicated by the floor is visually contracted above by the overlapping moldings, thereby emphasizing the planar arrangement of the composition. This same device—anticipated in the ex-Contini Madonna and Child—is also a feature of Piero's fragmentary fresco of Saint Julian from the church of Sant'Agostino in Sansepolcro (unfortunately, in that case the fragmentary state does not permit a proper appreciation of the effect Piero sought). Piero was never

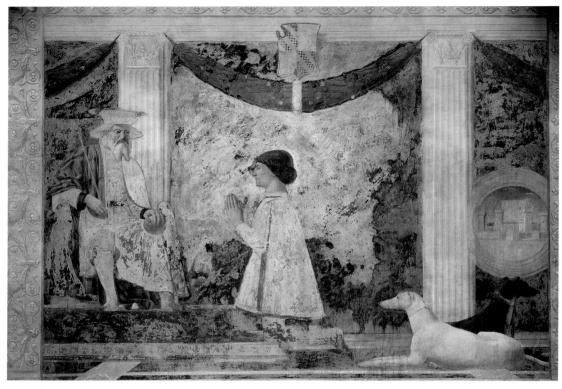

Figure 13. Piero della Francesca, Sigismondo Malatesta Praying before Saint Sigismund, 1451. Fresco, 101¼ × 135¾ in. (257 × 345 cm). Tempio Malatestiano, Rimini

interested in exaggerated effects of foreshortening or in an illusionism that called attention to itself, as, for example, Uccello was. Rather, he aimed to create a pictorial space that, while mathematically correct, did not disturb the integrity and solemnity of the planar design. This remarkable aesthetic—the "ability to unite pattern with depth which relates Piero with a painter temperamentally dissimilar from him, Cézanne"[28]—is first announced in the ex-Contini Madonna and Child, which makes it all the more curious that it is only in the last decade, after much resistance, that this picture has finally received the attention it

deserves and has begun to enter—rightly, in this writer's view—the canon of Piero's work.[29] Part of its neglect can be ascribed to the fact that for decades, it was known to scholars only through the photograph published by Longhi, which showed it in a much-cosmeticized state. After its exhibition in Florence in 1954,[30] it was not shown again publicly until 2007, following its all-important restoration.[31] Yet anyone who seriously examines the manner of painting the scrub vegetation and trees on the hills of the background landscape with daubs of paint will recognize Piero's familiar and utterly individual touch—a foretaste of what is

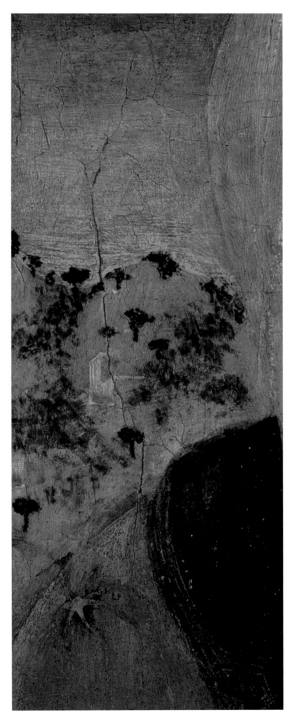

to come in his great Baptism of Christ painted for the church of San Giovanni in Val d'Afra upon his return to Sansepolcro sometime in the 1440s.

With the ex-Contini Madonna and Child, Piero shut the door firmly on his late Gothic training in Sansepolcro and embraced the advanced Renaissance culture of Florentine art. There is in the painting just that combination of experimentation, meticulous planning, and awkwardness in the articulation of the figures that we might expect from a talented painter with a provincial training who is attempting a new and far more complex aesthetic. The manner in which the Virgin grasps her child's left leg is unquestionably infelicitous, but seems to depend on an altarpiece in Città di Castello painted in the first decade of the fifteenth century by Spinello Aretino, whose work in and around Sansepolcro must have impressed the young Piero.[32] The gazes affectionately exchanged by the two figures, like the bird with wings outstretched in a desperate attempt to escape the tight grasp of the child, are characteristics Piero would eliminate from his later work, in which a courtly aloofness replaced the domestic charm so prized by Florentine patrons. But in the oval of the Virgin's face, her high forehead, and her broad somewhat flattened nose, we can perhaps see the beginnings of Piero's favored female type that, in the late Madonna and Child with Two Angels from Senigallia (see page 46), will achieve a marvelously nuanced perfection.

Figure 14. Detail of landscape in Madonna and Child (cat. no. 1)

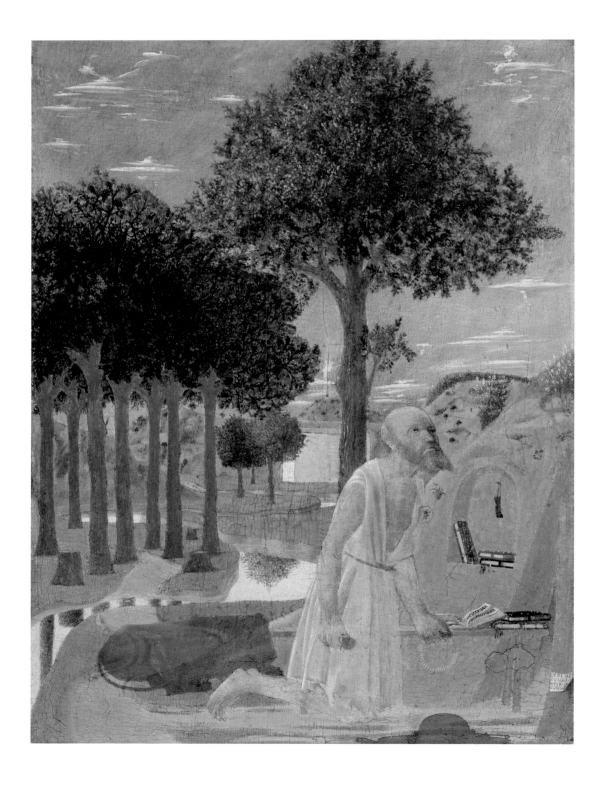

2. Saint Jerome in the Wilderness

1450. Tempera on wood (chestnut), 20⅛ × 15 in. (51 × 38 cm).
Gemäldegalerie, Staatliche Museen zu Berlin

How long Piero remained in Florence and when he returned to Sansepolcro remain uncertain. On September 6, 1440, a *Magistro Petro Benediti de Burgo* witnessed a document on behalf of the Florentine sculptor Michele da Firenze in the city of Modena, ruled by Niccolò d'Este, and if this person is in fact Piero della Francesca (whose father's name was, indeed, Benedetto), it means that perhaps he had already started his peregrinations among the courts of northern Italy.[33] It would not be surprising to learn that in the aftermath of the Battle of Anghiari, which was fought between Florentine and Milanese troops in the valley leading to Sansepolcro in late June of that year, Piero decided it was not a propitious moment to return home (in 1441, Sansepolcro became part of the Florentine state, with rigorous regulations imposed on commercial activity). Only after his father's death in 1464 did Piero, then over fifty, settle down in Sansepolcro, assume family and civic responsibilities (though he never married), and participate in the design and decoration of the family palace.[34] Despite his prolonged absences, he nonetheless maintained his contacts in the city and secured important commissions, only to repeatedly skip town and forcibly delay their execution. At some point in the 1440s (when exactly remains a matter of speculation), Piero was there long enough to paint the center panel of an altarpiece for the church of San Giovanni in Val d'Afra with the Baptism (see figure 3) — by common consent, the first work in which he demonstrated what he was capable of (the lateral panels and the predella were completed later by the Sienese painter Matteo di Giovanni). The only certain notice of Piero's presence is in June 1445, when he signed a contract to paint the altarpiece for the Confraternity of Santa Maria della Misericordia (he promised to complete the triptych within three years, but nine years later, he had barely made a start, and the bulk of work was concentrated between 1461 and 1462). Piero is documented next in his hometown in January 1454, to sign another contract; at the time, he had already begun work on the cycle of frescoes in Arezzo, which understandably assumed priority. The implications are that between 1440 and 1454, Piero was principally employed elsewhere: in Ferrara by the Marchese Leonello d'Este, in Rimini by Sigismondo Malatesta, possibly in Urbino by Federico da Montefeltro, and according to Vasari, in Loreto, where he would have worked once more with Domenico Veneziano.[35]

Vasari also claimed that Piero worked in Ancona, and Mazzalupi has established that in March 1450, *Magistro Petro Benedicti de Burgo Sancti Sepulcri* witnessed the will of the widow of Count Giovanni Ferretti, a member of one of the oldest families of the city. It was almost certainly for a member of a collateral branch of the family, Girolamo Ferretti, that Piero painted a devotional panel of Saint Jerome, still in its original

Figure 15. Nicola di Maestro Antonio d'Ancona, Saint Jerome in the Wilderness (lunette to an altarpiece), 1472? Tempera on wood, 79½ × 35⅛ in. (202 × 90 cm). Galleria Sabauda, Turin

engaged frame, which was acquired in 1922, by Wilhelm Bode for the Berlin museums.[36] Girolamo, it seems, took advantage of Piero's presence in the city—where the artist's principal task was to paint a fresco in the cathedral of San Ciriaco—to commission a work for private devotion that showed his patron saint doing penance in the wilderness. The subject was hardly uncommon, especially considering Girolamo's name, for images of the fourth-century theologian and historian—translator of the Bible from Greek and Hebrew into Latin—had become popular not only among members of monastic orders such as the Hieronymites but also among Humanist scholars who saw in Jerome a Christian scholar with a profound knowledge of classical learning and a mastery of Ciceronian Latin style.[37] We know that a scholar of the caliber of Guarino of Verona held in special veneration his painting of Saint Jerome in the wilderness by Pisanello. It elicited from him a detailed description that allowed him to exercise his considerable gifts as a Latinist and show

off his mastery of a classical literary form, the *ekphrasis*:

> ...the noble gift you have sent me, a picture of my beloved Jerome, offers a wonderful example of your power and skill. The noble whiteness of his beard, the stern brow of his saintly countenance — simply to behold these is to have one's mind drawn to higher things. He is present with us and yet seems also absent, he is both here and somewhere else: the grotto may hold his body, but his soul has the freedom of Heaven. However plainly the picture declares itself to be a painted thing in spite of the living figures it displays, I scarcely dare to open my mouth and whisper close-lipped rather than let my voice break loutishly in on one who contemplates God and the Kingdom of Heaven.[38]

Whether or not Girolamo Ferretti's response to the picture Piero painted for him was conditioned to a like degree by his reading of classical literature and whether or not he could articulate that response with a comparably composed elegance is doubtful. However, he showed his

esteem for the picture in a way we may find a good deal more eloquent and meaningful. In 1469, he contracted a stoneworker to build a chapel dedicated to his namesake in the church of San Francesco delle Scale, and for the lunette of the altarpiece that he commissioned from Nicola di Antonio di Ancona (Nicola di Maestro Antonio), he had Piero's composition replicated (figure 15), a sort of personal testimony to its devotional efficacy.[39]

The Ferretti Saint Jerome, if we may call it that, has the distinction of being the earliest signed and dated work by Piero; the curling cartellino affixed to the trunk of the tree at the lower right is inscribed in Humanist-inspired Roman letters: PETRI DE BURGO OPUS MCCCCL.[40] Unfortunately, like the ex-Contini Madonna and Child, the picture has come down to us in a badly compromised state, having lost all surface refinement through a harsh cleaning in the distant past. So altered was it by repainting that for many years, scholars refused to accept it (Longhi did not discuss it in his 1927 book and in subsequent editions allowed only that Piero had a hand in its execution and left it unfinished). The extensive retouching was finally removed in a restoration undertaken between 1968 and 1973.[41] Thin though the paint surface is, there really can be no question concerning the authorship of the work. Indeed, because of its date, the picture provides a crucial reference point for anyone attempting to establish a chronology for the artist.

The ascetic saint is shown in a river landscape, next to a grotto or cave into which has been carved an arched niche neatly containing books and a leather case for writing implements. Beside the saint is a simple bench on which are three more volumes, one lying open, its pages fluttering. This is clearly meant to be Jerome's retreat near Bethlehem, and the building we see in the background is a reference to the hermitage he founded there. His chest exposed, he kneels on the barren ground, counting the beads of his paternoster that he holds in his left hand, while with his right, he prepares to beat his breast with a stone. The object of his meditation is a thin wooden cross attached to the tree trunk, toward which his carefully foreshortened head is raised. Lying on the ground in front of him is his cardinal's hat (an office he never held but that was commonly accorded him) and behind him is the lion that, legend had it, became the saint's constant companion after he removed a thorn from its paw. It is now easy to see that the two attributes, the hat and the lion, were added by Piero after he had first painted the landscape, which is the part of the picture that seems to have really interested him (figure 16). If we divide the picture down the middle, we find that the entire left half is given to a vista clearly based on Piero's memories of his native Tiber Valley, backed by the foothills of the Apennines. He has taken particular delight in capturing the calm reflective surface of the river. Like his alter-ego, Poussin, would be two centuries later, Piero was deeply interested in the science of optics, but he also appreciated the way the reflections of tree trunks and cubic buildings could enhance the vertical accents and reinforce the scanning of his compositions.[42] When freshly painted, the landscape must have had some of that serene springtime beauty we find in the Baptism of Christ, though it was far from the crystalline purity of the river landscape that we glimpse between the advancing troops of Constantine and the retreating soldiers of Maxentius in the frescoes at Arezzo (figure 17). That lay in the future. As in the Baptism, the placement and diminution of the trees—are they intended as an ilex grove

29

Figure 17. Detail of landscape in the scene of Constantine's Victory at the Milvian Bridge, San Francesco, Arezzo

(*lecceto*), so often associated with Augustinian hermitages?—define the gradual progression into depth. Some have been felled—a reference to Matthew 3:10, in which John the Baptist invokes the punishment of God on those who do not repent and change their ways: "Even now the axe is laid to the root of the trees. Every tree therefore that does not bear good fruit is cut down and thrown into the fire" (Jerome, it should be noted, wrote a commentary on the Gospel of Matthew). A path suggests Jerome's spiritual journey through this metaphorical forest, perhaps not the *selva oscura* of Dante but a forest of the soul nonetheless.[43] Indeed, Piero's painting is unusual for not creating a stronger contrast between the harshness of Jerome's desert retreat and the world he has left behind. That occurs in a second devotional panel that treats the same theme but is of quite another character.

Figure 16. Detail of landscape in Saint Jerome in the Wilderness (cat. no. 2)

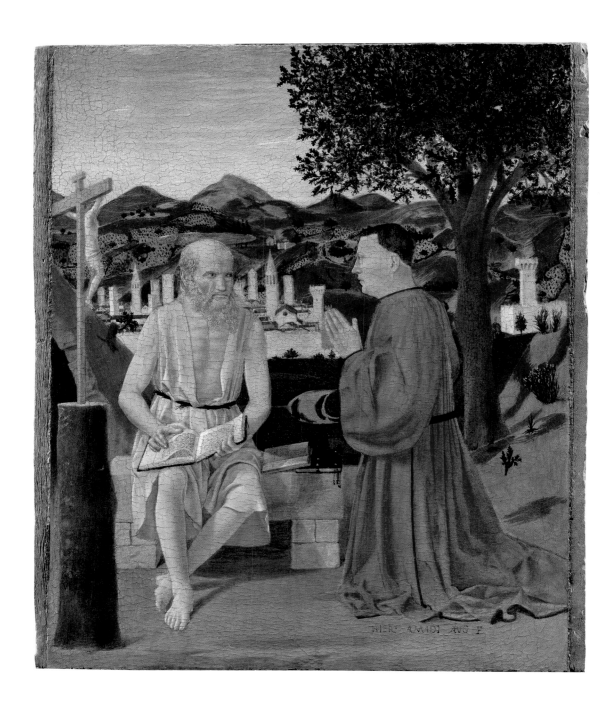

3. Saint Jerome and a Supplicant

Ca. 1460–64? Tempera and oil on wood, 19½ × 16½ in. (49.4 × 42 cm); painted surface: 19½ × 15½ in. (49.4 × 39.5 cm).
Gallerie dell'Accademia, Venice

The small panel of Saint Jerome and a Supplicant in the Gallerie dell'Accademia, Venice, is among Piero della Francesca's most haunting and mysterious creations, and it is one of his least studied masterpieces.[44] We have no firm record of the picture before 1812, when it belonged to Count Bernardino Renier in Venice; it was given to the Gallerie dell'Accademia by his widow, Maria Felicita Bertrand Hellmann, in accordance with the count's will.[45] Not surprisingly, the circumstances surrounding the panel's commission—the when, where, and who—long have been the subject of debate, despite the fact that the name of the supplicant is clearly indicated on the panel in handwritten Roman script. The picture has been dated early in the artist's career, about 1440–50, and also has been considered one of his last pictures, from about 1475.[46] It has been thought an important document of Piero's influence on Venetian painting in general and on the art of Giovanni Bellini in particular, and alternatively, of peripheral importance.[47]

In his Flagellation of Christ in Urbino (figure 18)—another work that stands apart in the artist's oeuvre but may not be far removed in date[48]—Piero placed his protagonists in an ideal urban setting meticulously laid out on a perspectival grid, while in the Accademia panel, the two figures that command the foreground are measured against a carefully articulated landscape of intense beauty.[49] With the possible exception of the great Resurrection decorating a wall in the Council Chamber of his native Sansepolcro (figure 19), Piero did not describe a like harmony between man and nature in any other work. The novelty of the picture was fully understood by Longhi, who in his 1927 monograph described it in appropriately poetic terms.

> Here men and saints, equal in their landscape surroundings, meet and establish a rustic familiarity, the significance of which is immersed in the spectacle of the hot afternoon. Gone is the idea of painting as a beautiful mirror with a dogmatic centrality, since the mathematical center of the picture is occupied by the distant appearance of a city constructed by men; and from all sides, from the cut trunk in the foreground to the tree behind the supplicant, to the shimmering zones of mountains and sky, there is an unfettered immersion in the space of people and things. Man thus loses his place as the measure of all things, as in those days it was thought by Florentines — terrible anthropomorphists — and so, too, he loses his usual points of reference.[50]

The ascetic Saint Jerome is shown seated on a bench—rustic but of solidly constructed stone, unlike the rickety wood bench in the Berlin picture—near his cave dwelling, together with a robed supplicant. Unusually, Piero has omitted both Jerome's lion and his cardinal's hat, choosing instead to emphasize the fourth-century saint's scholarly activity. The meeting place of the two men is a barren plateau above a verdant

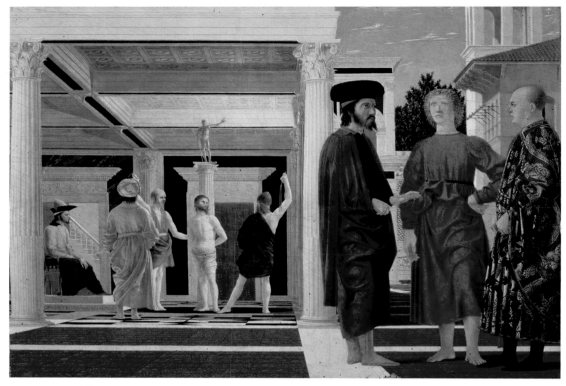

Figure 18. Piero della Francesca, The Flagellation of Christ, ca. 1455–60? Oil and tempera on panel. 23 × 32⅛ in. (58.4 × 81.5 cm). Galleria Nazionale delle Marche, Palazzo Ducale, Urbino

valley bordered by distant hills, the slopes of which are dotted with vines that Piero has rendered with his characteristically impressionistic brushwork (unfortunately, the copper resinate greens have oxidized to an olive brown, so that much of the springtime freshness has been lost). Nestled in the valley is a walled town, the towers of which—compositely defensive, private, and ecclesiastical—cannot help but recall those of Sansepolcro itself, though the view is hardly topographical. (It has been observed that the chimney pots are of a type found in Venice, but similar ones appear in the city in the right background of Piero's late Nativity in the National

Gallery, London, which was clearly intended to represent Sansepolcro.) A castle or fortress is sited strategically on the slopes of one hill, overlooking the city, while in the distance are the facade and bell tower, or campanile, of a convent (figure 20). Nothing could be further from the simple die-board landscape of the Berlin painting. The bearded ascetic, his tunic bound at the waist with thorny branches, is seated frontally, his legs crossed in a casual demeanor, his right hand thumbing through the leather-bound book he holds on his lap. His index finger is raised in suspended movement, suggesting that he is comparing texts for one of his critical

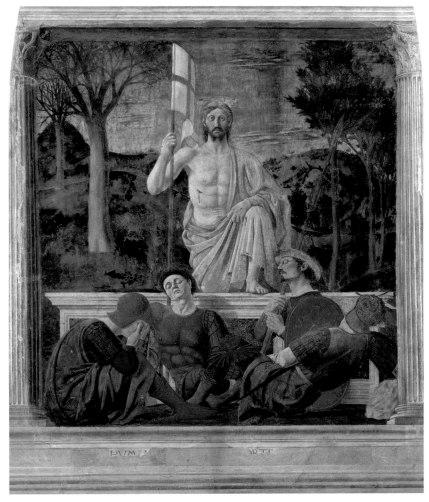

Figure 19. Piero della Francesca, The Resurrection of Christ, ca. 1458–59. Fresco, 89 × 79 in. (226.1 × 200.7 cm). Pinacoteca Comunale, Sansepolcro

commentaries or translations when interrupted by the arrival of the well-attired supplicant who, having evidently followed the path that leads from the towered city to the barren heights, now kneels before the hermit, his clasped hands raised in an attitude of reverence.[51] Their locked gazes create a shared space and time, though the two men come from different worlds, their lives separated by a millennium. Below the supplicant, printed in elegant script, is his name: HIER[ONYMVS] AMADI AVG[USTINI] F[ILIVS], which is to say, Girolamo Amadi, son of Agostino.[52] We know of a person of this name; he was a member of the Lucchese community resident in fifteenth-century Venice, and his wealth came from the silk and textile trade. But

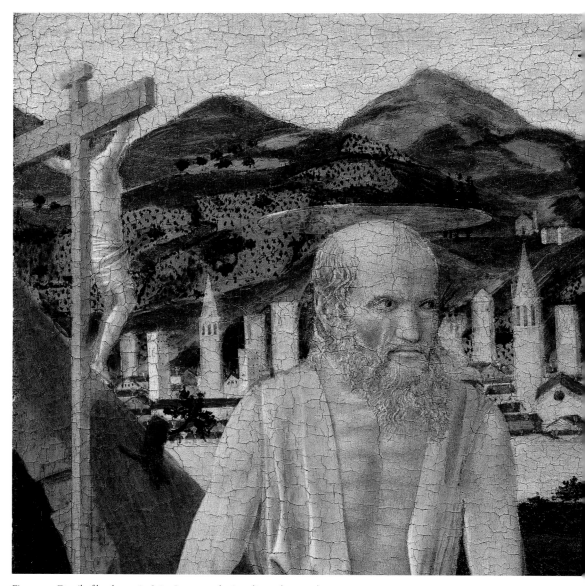

Figure 20. Detail of landscape in Saint Jerome and a Supplicant (cat. no. 3)

for the moment, it is enough to note that what has brought him to this barren place is his desire to pay homage to his patron saint, who presents himself not as a paradigm of the penitent sinner — though a delicately described crucifix, with drops of blood coursing down Christ's steeply foreshortened arm, has been set on the tree stump — but as the quintessential scholar.

Piero has transformed this imaginary meeting into a sacred event through a series of

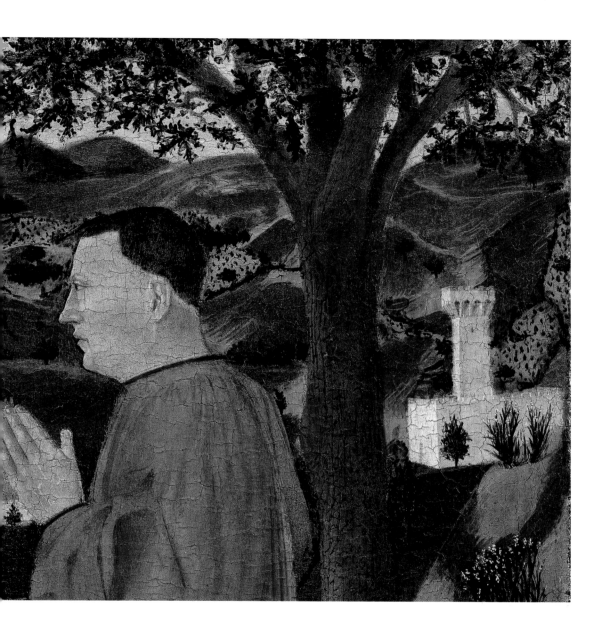

carefully considered contrasts. There is the obvious one of age and dress. But no less important is the counterpoint of the sawn stump on which Jerome's crucifix is propped and the flourishing oak tree that promises Amadi a shady refuge from the noonday sun (that it is an oak tree is clear from the shape of the leaves, just as one can identify the yellow blossoms of broom, or *ginestra,* on the slope behind the tree). Piero has employed his favorite device of pairing a

figure posed frontally with a second one presented in profile. It is something we find in his early Baptism (see figure 3), in which Christ stands in the River Jordan in a rigidly frontal stance like an ancient idol, while John the Baptist, his pose conveying an action frozen in time, is shown in profile, as Exekias might have painted him on an amphora in sixth-century B.C. Athens.[53] In similar fashion and to similar effect, in the cycle of frescoes in San Francesco, Arezzo, of the 1450s, the Queen of Sheba, shown in profile and bowing, pays ceremonial homage to King Solomon, while he, magnificently garbed in a blue brocaded robe with a cloak of cloth of gold and in a hieratic nearly frontal position, acknowledges her by taking her extended hand. In the scene of the Annunciation, we find the silhouetted profile of the archangel Gabriel, who advances with muffled footsteps across the brick paved forecourt of the Virgin's house, played against her sacral frontality. And in the Flagellation (see figure 18), the three attendants in the foreground who meet in detached conversation are depicted in three-quarter, frontal, and profile views, the profile reserved for the figure with portrait-like features. In Piero's votive fresco in the Tempio Malatestiano in Rimini (see figure 13) — the work closest to the little panel in Venice in compositional structure and function — Sigismondo Malatesta is shown in profile, the pose favored by fifteenth-century painters for donor as well as court portraits, and kneeling before his patron Saint Sigismund, who, elevated on a dais and holding an orb, is angled only slightly from a full frontal position, in acknowledgement of the tyrant's presence. Their poses are elegantly mirrored by the two thoroughbred greyhounds who lounge on the marble pavement of the audience chamber, their placement audaciously redressing the asymmetry of the scene

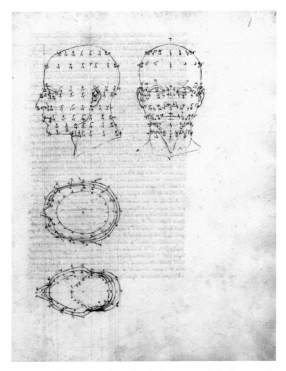

Figure 21. Illustration of two heads from Piero della Francesca's *De prospetiva pingendi*, Biblioteca Palatina, Parma

self-evidently conceived so that Sigismondo would command center stage.[54] That this combination of frontal and profile views had special significance to Piero is evident from an illustration in his treatise on painting, the *De prospetiva pingendi* (figure 21), in which two heads, one in profile and the other full face, are presented as demonstrations for perspectival rendering. In other words, the pairing of the frontal and profile was for him archetypal. The rhapsodic view behind these two figures is recognizably of the Tiber Valley. The hills behind the tidy walled city will be familiar to anyone who has driven the tortuous road Piero himself was obliged to take whenever he left his native Sansepolcro to work for the Malatesta and Montefeltro courts

at Rimini and Urbino. The view need not have carried any more significance than does Cima da Conegliano's persistent inclusion of his native town in the landscapes of his devotional pictures; it is, rather, a testament to Piero's response to his native surroundings. The composition is conceived with Piero's exquisite sense of geometry, his preferred alternation of solid and void, and his inimitable manner of linking, through juxtaposition, the near and the distant. Thus, the vertical axis is indicated by a series of aligned motifs that interlock foreground and background: the support of the stone bench, the curving road in the middle ground, the crenellated tower at the extreme edge of the walled city, and the leafy edge of the crown of the tree that fills the upper right of the picture, its dense foliage setting off the limpid sky on the left.

Counterbalancing the bilateral planar alignment of the figures is an emphatic diagonal established by the tree stump in the left foreground and the tree and castle/fortress on the right, and this angle is underscored further by the angled position of the crucifix. Jerome's head is shown against the plethora of vertical accents of the distant city, while the craggy profile of the fifteenth-century supplicant is set off by the irregular curving forms of the hills.[55] These pictorial devices not only create the kind of richly articulated pictorial unity commonly associated with Cézanne and Seurat—both of whom studied copies of Piero's Arezzo frescoes in the École des Beaux-Arts in Paris—but they also underscore the confrontation of two worlds, that of the saint who has renounced the urban life of the city behind him for the physically barren but spiritually rewarding world of the ascetic and that of Girolamo Amadi, who despite his pilgrimage to the saint's rustic dwelling and his attitude of reverence, is inevitably linked with the inviting fields and vineyards visible behind him no less than with the fortress-like castle or villa positioned in the landscape like a protective sentinel. He conspicuously has not traded his expensive red gown for the simple clothes of a member of a secular order.[56] As we have noted, in no other painting—not in the hushed radiant world of his early Baptism of Christ, with its expansive planar view past the stumps of hewn trees toward a distant city often identified with Sansepolcro backed by the curves of distant hills, nor in the portrait diptych in the Uffizi (see figure 31), with its Eyckian-derived division between near and far and its acute attention to atmospheric effects, nor even in the late Nativity in London, with its contrasted views of a city dominated by a church and tower and a river valley bathed in pearly light—does Piero achieve such a complex and compelling vision of man and nature. The only work that offers an analogy is the Resurrection. Comparing the layered background hills of that masterpiece with the more schematically conceived landscape that serves as a backdrop for the scene of the discovery of the crosses in the fresco cycle at Arezzo provides one indication for dating this Saint Jerome. Underscoring the exceptional character of the picture is the complex problem Piero has set up for the projection of the shadow cast by Jerome's crossed legs and body on the flat surface of the arid ground, on the upright surface of the bench, and extending across the curved pages of the open book (the book was painted over the curvature of the plateau and landscape, and these elements have bled through, somewhat compromising the clarity of the shadow). To achieve this, Piero must have modeled a clay figure that he observed under controlled lighting.[57] The projection of shadows was to become increasingly important in Piero's work of the

1460s, but it is the Saint Jerome that set the stage for those developments.

Piero has rendered his name, PETRI DE BV[R]GO S[AN]C[T]I SEPVLCRI (by Piero of Borgo Sansepolcro), as though carved into the tree stump supporting the crucifix, making this one of only four signed pictures (figure 22). The Roman-styled capital letters—*lettere antiche*, derived from the study of classical epigraphs—are among the finest from Piero's hand, and moreover, they have been foreshortened in accordance with the curved surface they adorn. The letters are more accomplished than those on the Berlin painting and are as elegant as those Piero painted as though incised onto the parapet of the votive fresco of Sigismondo Malatesta before his patron saint or those that appear on the dais of Pilate's throne in the Flagellation (figure 23). Although Piero's ancient-styled letters never achieved the archaeological perfection of those of his Paduan contemporary Andrea Mantegna, they were clearly an emblem of the Humanist culture he embraced. For that reason, it is curious that the least consistent, both in spacing and in the varied bastardized shapes of some of the letters, are the long inscriptions on the portraits in the Uffizi painted for Federico da Montefeltro, who took a special interest in such things.[58]

Piero's name is also inscribed in uppercase Roman letters at the head of his handwritten treatise on perspective (figure 24), conceivably the version he sent to Federico da Montefeltro about 1480 (Biblioteca Palatina, Parma, MS 1576),[59] and we also possess an autograph copy of the *Trattato d'abaco* (Biblioteca Laurenziana, Florence). It is thus safe to say that the inscription in capital letters beneath the supplicant is not in Piero's hand but was added by a later owner (figure 25). Nonetheless, the form of the letters

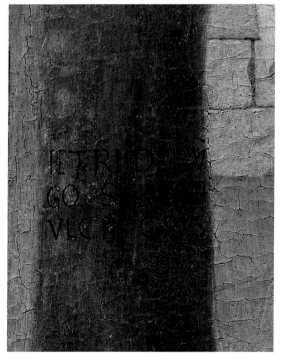

Figure 22. Detail of inscription on tree on the left in Saint Jerome and a Supplicant (cat. no. 3)

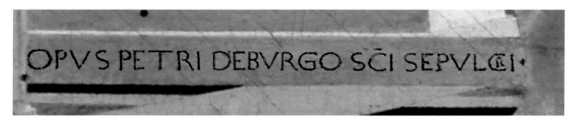

Figure 23. Detail of inscription in The Flagellation of Christ (figure 18)

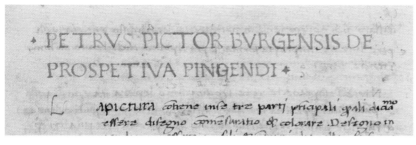

Figure 24. Detail of Piero's name on the opening page of *De prospetiva pingendi*

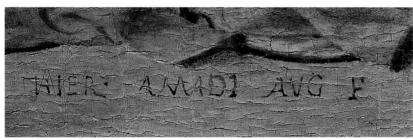

Figure 25. Detail of hand-written inscription beneath the donor in *Saint Jerome and a Supplicant* (cat. no. 3)

suggests a date no later than the early sixteenth century, and it is difficult to understand how its importance for identifying the sitter could be as casually dismissed as it often has been.

Originating from Lucca, in Tuscany, the Amadi may have settled in Venice as early as the thirteenth century but certainly by 1303, when we hear of a Marco Amadi.[60] They began as dyers in Murano, and it is Girolamo's grandfather Amato Amadi and Amato's brother Francesco who increased the family's status and moved to Venice as merchants in the silk trade. The family achieved considerable wealth and standing, establishing business ties as far afield as Nuremberg and even representing the Republic of Venice on diplomatic missions. The brothers acquired a large palace in the parish of San Giovanni Crisostomo, near the confraternity of silk traders, in the heart of the Lucchese community (see photo on p. 63). Amato Amadi had at least eight children, the youngest of whom was Girolamo's father, Agostino, who was born

after 1409, when his father married for the second time. This means that Agostino cannot have married before 1430 and that Girolamo, Agostino's third of six children (five male and one female), is unlikely to have been born before about 1433–35. Girolamo married twice, both times to women of Lucchese families.[61] He died in 1507, when his brother, also named Francesco (after their great uncle), added a codicil to his will that transferred what would have gone to Girolamo to Girolamo's son Domenico. We might imagine Domenico as the person who added the identifying inscription to the picture—a not uncommon way of perpetuating the memory of a parent or loved one. We know that Francesco was schooled in Greek as well as Latin and in 1458 was captain of a ship in the Venetian fleet. In 1459, he was head of the *Compagnia della Calza de' Fedeli*, which organized entertainments and plays in the city, and in 1475, he was sent as an emissary to Tuscany to drum up support for a war against the Ottomans.[62]

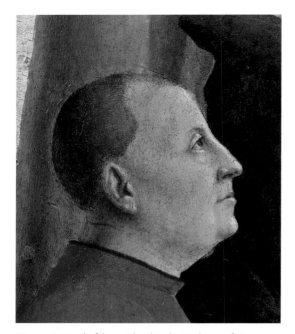

Figure 26. Detail of donor's head in the Madonna of Mercy Altarpiece, Pinacoteca Comunale, Sansepolcro

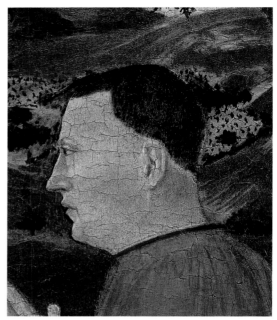

Figure 27. Detail of supplicant's head in Saint Jerome and a Supplicant (cat. no. 3)

Did Girolamo share the interests and achieve the prestige of his brother? Impossible to say, though the picture seems to indicate that he too had scholarly interests. Commercial links forged through the textile trade and the Amadi's continued identification with their Tuscan roots suggest a possible explanation for why this transplanted figure of Lucchese descent might prefer to hire a Tuscan rather than a Venetian painter for a personal record of his devotion to his patron saint. Where and when the commission took place remain a matter of conjecture, since we know of no trip by Piero to Venice and no trip by Girolamo to Tuscany, but this has not stopped scholars from floating possible scenarios. It has, for example, been conjectured that their encounter took place in Piero's native Sansepolcro, where the Amadi may have been interested in woad to extract the blue dye used in coloring textiles.[63] Perhaps a more likely scenario is that their encounter occurred in one of the cities along the Adriatic coast, where so much Venetian commercial activity took place and where we know that Girolamo's grandfather Amado and Amado's brother Francesco established business connections.[64] As we have seen, another of Piero's patrons, Girolamo Ferretti, was a textile merchant from Ancona. A third possibility is that Piero's compatriot, Luca Pacioli, who was in Venice beginning in 1464, was the conduit. What must be firmly rejected are the various attempts that have been made to collapse all the middle-aged men with short-cropped hair who occasionally appear in Piero's paintings into a single person from Arezzo or Sansepolcro.[65] Both the nineteenth-century provenance of the painting from Venice and the sixteenth-century inscription plainly argue against identifying the

supplicant as one of Piero's compatriots. More-over, if the morphologies of the various figures in question are compared, it becomes evident that the similarities are more generic than real (for example, the rounded top of Girolamo's ear, his slanted forehead, straight nose, small eyes, and broad fleshy face are quite different from the pointed ears and large-eyed features of the kneeling man—probably a member of the Pichi family—beneath the Madonna of Mercy, with whom he is most often compared) (figures 26 and 27).

When was the Gallerie dell'Accademia picture painted? Although commonly thought to be more or less contemporary with the Saint Jerome in Berlin, it is, as already observed, surely a good deal later. On the other hand, it cannot be as late as the portraits of Federico and his wife Battista Sforza in the Uffizi, in which the distant landscape is conceived in a very different, van Eyckian-inspired fashion.[66] A date after 1460 would place it in close proximity with the great Resurrection, with which, as we have noted, it bears certain affinities in the relation of

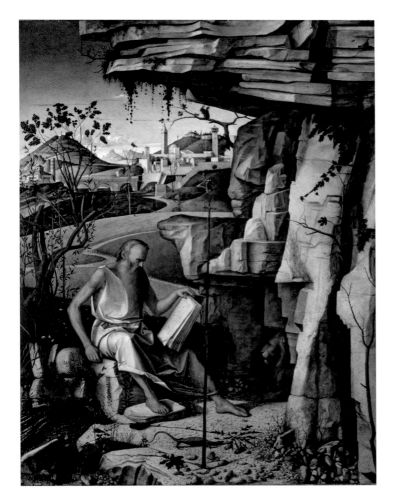

Figure 28. Giovanni Bellini, Saint Jerome in the Wilderness, early 1480s. Oil on panel, 59¾ × 44¾ in. (151.7 × 113.7 cm). Galleria degli Uffizi, Florence

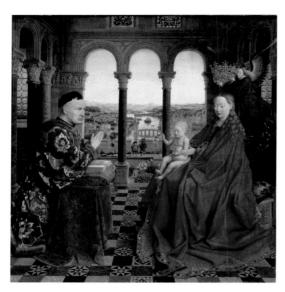

Figure 29. Jan van Eyck, The Virgin and Child with Chancellor Rolin, ca. 1435. Oil on panel, 26 × 24⅜ in. (66 × 62 cm). Musée du Louvre, Paris

the figures to the background hills and would not be contradicted by the apparent age of the sitter. Assuming that the picture was visible in Venice at this early date, it becomes possible to posit its intersection with a series of marvelously descriptive works by Giovanni Bellini in which Jerome is shown on a plateau by a rocky cave (figure 28), deeply engrossed in reading rather than in performing penance—though Bellini always included Jerome's traditional lion.[67] The elaborate rock formations in Bellini's pictures have been shown to be inspired by a small painting by Jan van Eyck that was taken to Italy by its owner, Anselmo Adorno, and was visible in Venice in February 1471. It has been said often that Piero's picture too is indebted to the example of Jan van Eyck and Rogier van der Weyden, whose paintings he had possibly seen in Florence in 1439–40 and certainly had occasion to study at the Este court in Ferrara, that of Federico da

Montefeltro in Urbino, and the Sforza court in Pesaro.[68] In a general way, this is true; the preference of those artists for the detailed rendition of natural phenomena and their masterly handling of light—sharp and almost airless in the case of Rogier, soft and atmospheric in van Eyck—clearly fascinated Piero, no less than their use of the oil medium. Yet, it has been observed that it was only in the 1460s, when Piero was working for the court of Urbino, that "Netherlandish painting attracted the painter from Borgo in all its most subtle aspects, not only in the depiction of small details but above all in the lustrous effects obtained from reflected light."[69] Moreover, the work that is most often brought into the discussion, Jan van Eyck's painting of Chancellor Nicolas Rolin kneeling before the Virgin and Child in the Louvre (figure 29), is not only unique in van Eyck's oeuvre, it is a picture Piero cannot ever have seen.[70] What would appear to be at issue is the way both van Eyck and Piero independently adapted a formula associated with votive altarpieces and frescoes for a highly personal work created for private devotion. Piero's fresco in the Tempio Malatestiano in Rimini of Sigismondo Malatesta kneeling before his patron saint—though hardly in intimate colloquy—is an example of just such a votive work (see figure 13). For the rest, there is little in Piero's picture that required the example of a specific Netherlandish painting. The acuity of the landscape and the effect of measured distance have a Florentine precedent in Domenico Veneziano's astonishing tondo in Berlin of the Adoration of the Magi, which possibly was painted during the time Piero assisted him (figure 30).[71] There is also a great difference between the very fluid way Piero described the transition from foreground to background and the tendency in those Netherlandish works with which

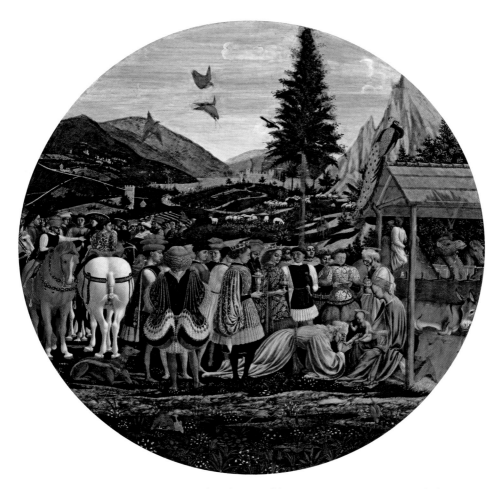

Figure 30. Domenico Veneziano, The Adoration of the Magi, ca. 1439–41. Tempera and oil on wood, diameter 33⅛ in. (84 cm). Gemäldegalerie, Staatliche Museen zu Berlin

it is sometimes compared to omit any middle ground and to render the background as a distant vista seen from an elevated point—as happens in Piero's paired portraits in Florence of Federico da Montefeltro and Battista Sforza (see figure 31).[72]

One of the most cultivated rulers of his time— he had been schooled at Mantua by the greatest teacher of his day, Vittorino da Feltre—Federico was an ardent admirer of Netherlandish painting. His kinsman and counselor Ottaviano Ubaldini

della Carda is known to have owned several works by van Eyck, and Federico himself managed to secure the services of at least two Netherlandish artists who could satisfy his desire for the kind of descriptive detail for which they were celebrated. So it is not surprising that it was in Piero's paintings for Federico that the example of Netherlandish paintings in general and those by Jan van Eyck in particular had a transformative effect on his art and resulted in one of his most entrancing masterpieces.

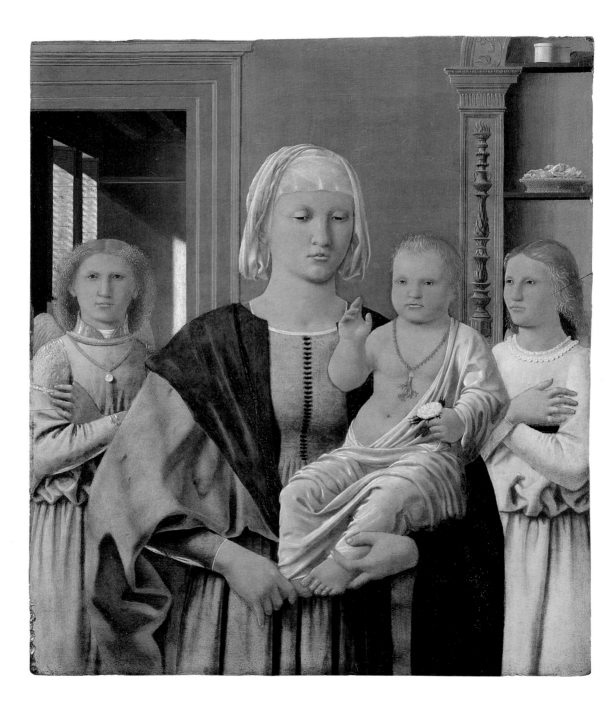

4. Madonna and Child with Two Angels

Ca. 1464–74? Tempera and oil on wood (walnut), 24¹¹⁄₁₆ × 20³⁄₁₆ in. (62.7 × 51.6 cm).
Galleria Nazionale delle Marche, Palazzo Ducale, Urbino

Piero's modest-sized panel of the Madonna and Child in a domestic interior holds a special place in his career.[73] Aside from the ex-Contini painting, which, as we have seen, must be a product of his work in Florence under Domenico Veneziano, it is the only work to come down to us in which he treats the most conventional theme in Italian art and the one most closely associated with private devotional practice. In this small panel, Piero takes his art in a new direction, striking a singular "accord between the monumental and the intimate"[74] and conferring a tone of ceremonial gravity on what is ostensibly an informal private encounter between the viewer/worshiper and the object of his or her devotions. The abstracting world of mathematics and geometry that lies at the core of his art and the descriptive naturalism for which Netherlandish painting was admired are miraculously combined, and Piero's fascination with light and the projection of shadows acquires a profoundly poetic dimension — all of which suggests the privileged circumstances of this work's commission.

There is no record of the picture prior to 1822, when it is first recorded in a chapel in the church of Santa Maria delle Grazie in the town of Senigallia, about thirty kilometers north of Ancona on the Adriatic coast. This cannot have been its original destination, for the size and character of the picture are unsuited to a function as an altarpiece, and construction of the

Franciscan church dates from 1491. This is just a year before Piero's death and well after he more or less had abandoned painting in favor of writing theoretical treatises and moreover, had lost his sight (we actually know the name of the person who, as a youth, had led the aged artist around the streets of Sansepolcro). In the event that construction of the church was promoted by the young ruler Giovanni della Rovere, nephew of Pope Sixtus IV and husband of Federico da Montefeltro's daughter Giovanna, there is the possibility that the picture was painted for the couple and given or bequeathed by them to the church, where Giovanni, a Franciscan tertiary, was buried.[75] We know of analogous cases in which a person left a favorite devotional image to a foundation with which he or she had close ties.[76] This is, of course, mere speculation, complicated by the fact that the couple moved from Rome to Senigallia after 1480, far too late a date for the picture. Another, perhaps more plausible scenario would have it that the work was commissioned from Piero by Federico and subsequently given by him to his daughter on the occasion of her betrothal in 1474 or her marriage in 1478 to the pope's nephew, who had been educated "like a much loved son" at the court of Urbino.[77] The most auspicious time for such a gift would have been in 1474, when the eleven-year-old Giovanna was promised in marriage and Sixtus IV conferred on his sixteen-year-old nephew rulership of Senigallia,

appointed Federico commander (*Gonfaloniere*) of the papal troops, and granted him the title of Duke of Urbino. If this scenario is correct, then this Madonna and Child would be the latest of a number of works Piero carried out for the court.

What do we actually know about Piero's relations with Federico da Montefeltro? As is so often the case, we are remarkably short on particulars.[78] Indeed, were it not for a payment of April 8, 1469, we would have no documentary record that he ever visited Urbino. On that day, Giovanni Santi, the future father of Raphael, was reimbursed for expenses incurred during Piero's visit with a view to painting an altarpiece for the Confraternity of Corpus Domini. Presumably, he had been recommended to the confraternity by Federico himself, since in the finished work, the ruler appears with other members of the court. In any event, Piero did not accept the commission. There is, indeed, reason to think that by that date, his work at the court was drawing to a close, both because of his age—he was then nearing sixty—and because Federico's time was increasingly occupied with the construction of his palace. When it came to decorating the interior, Federico turned instead to artists with Netherlandish training. Thus, when, sometime after 1469, Justus of Ghent departed for Italy, he was recruited by Federico to paint a cycle of famous men to decorate the Ducal Palace *studiolo*. In 1473–74, Justus also was engaged by the confraternity to paint their altarpiece.[79] Following his departure, Federico hired another exponent of Netherlandish style, a Spaniard we know only as Petrus Hispanus (probably but not certainly Pedro Berruguete), who is documented as living in Urbino by 1477.[80] He it is who, about 1476–77, painted a magnificent full-length portrait of the duke with his son Guidobaldo and was asked to repaint Federico's

hands in Piero's Montefeltro Altarpiece (see figure 4).[81] All this strongly suggests that by 1472/73, Piero's place at the court had been filled by painters with Netherlandish training.

The most likely moment for an extended stay by Piero would have been between 1463 and 1466, for it was only after Federico's defeat of his archrival Sigismondo Malatesta in 1462/63 that he was able to return to Urbino and lay out his plans for the expansion of the Ducal Palace, the exquisite detailing of which seems reflected in the Madonna and Child.[82] As for Piero, between November 1462, when he was recorded in Sansepolcro as a witness to a will, and July 1464, when he was engaged to paint a banner for a confraternity in Arezzo, there is no notice of his whereabouts. The same is true between July 1464 and December 1466, when he was hired by another confraternity in Arezzo to paint a banner of the Annunciation, which he only completed two years later. After 1466, Piero concentrated his efforts on finishing two major altarpieces, one for a convent of nuns in Perugia that he completed by June 1468, and the other for the Augustinians in Sansepolcro that he finished the following year. In the 1470s, we find Piero increasingly fulfilling family and civic duties in Sansepolcro and engrossed in the production of his theoretical treatises—though he was still up to travel as late as May 1482, when he rented a room in the seaside town of Rimini, where he had worked three decades earlier.

Perhaps the most eloquent testimony to the kind of rapport that seems to have existed between Federico and Piero during these eventful years is the fact that after the death of the duke in 1482, the aged artist dedicated his treatise on Euclid's five regular geometric bodies, the *Libellus de quinque corporibus regularibus*, to Federico's heir, Guidobaldo. He recalled his

deep attachment to the Montefeltro family and expressed his hope that this, his most ambitious and innovative treatise, would find a place in the Ducal Palace library—the most prestigious of its day—next to his work on perspective, which he had sent to Federico some years earlier. That these treatises would have been of particular interest to Federico there can be no doubt. His biographer, the Florentine bookseller Vespasiano da Bisticci, specifically noted among the duke's many cultural accomplishments that "he was a skilled geometrician and arithmetician." Mathematics doubtless had been inculcated at school under Vittorino da Feltre, who had studied Euclid, and was no less prized by Ottaviano Ubaldini, who was deeply involved in all cultural in addition to political matters at court. Vespasiano informs us that the duke's knowledge extended to discussing mathematics with the famous German scholar Paul of Middelburg during a visit to the court in 1481. But the duke's dominant passion unquestionably was architecture. "As to architecture," Vespasiano informs us, "it may be said that no one of his age, high or low, knew it so thoroughly. We may see in the buildings he constructed, the grand style and the due measurement and proportion, especially in his palace, which has no superior amongst the buildings of the time."[83] By 1464, he had engaged the Dalmatian architect Luciano Laurana for the project, and that autumn, he had as a guest Leon Battista Alberti, occasioning, it must be imagined, long discussions about the palace as well as the ideas expressed in Alberti's groundbreaking architectural treatise, the *De re aedificatoria*, a magnificent edition of which Federico later owned.[84] Not coincidentally, in the four pictures by Piero that can be associated with the Montefeltro court, these interests are much in evidence.

By common consent, the earliest of these—it may date from the mid- to late 1450s—is Piero's Flagellation (see figure 18).[85] Although it sometimes has been proposed that Federico was not responsible for its commission, it is difficult to imagine who else might better have appreciated the remarkably complex perspective construction and the sophisticated knowledge of architecture this picture demonstrates. Indeed, one wonders if Piero did not conceive the picture as a sort of demonstration of what he could do.

There followed Piero's famous portraits in the Uffizi, Florence (figure 31), in which Federico and his esteemed wife, Battista Sforza, are shown before a continuous distant landscape—Piero's idealized evocation of a peaceful and prosperous Montefeltro state (the lake, for example, is pure invention). The panels perhaps were painted to commemorate the marriage of the couple in 1460 but not commissioned until after Federico's victory over Sigismondo in 1462/63.[86] The two figures are shown again on the reverse side of each panel, seated in triumph on allegorical carts—Federico crowned by Fortune or Fame and accompanied by the four Cardinal Virtues and Battista attended by figures of Chastity and Modesty and the three Theological Virtues (figure 32). Again, a landscape vista, haunting in its stillness, with a morning mist mantling the distant hills and boats gliding across the mirror-like surface of a lake, forms a continuous background across the two pictures, which originally were hinged to form a diptych, while on feigned marble parapets are laudatory verses in Latin. If the rigorously classical meter of the verses attests to Federico's passion for the writers of ancient Rome copiously represented in his library, the meticulously descriptive technique and the atmospheric rendering of the landscape unquestionably pay homage to

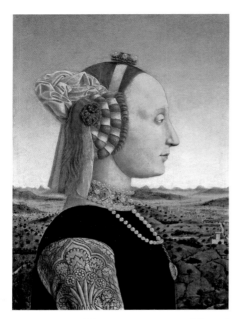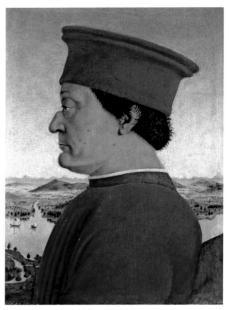

Figure 31. Piero della Francesca, Portraits of the Duke and Duchess of Urbino, Federico da Montefeltro and his Wife Battista Sforza, diptych, ca. 1464/72? Tempera on panel, each: 18½ × 13 in. (47 × 33 cm). Galleria degli Uffizi, Florence

CLARVS INSIGNI VEHITVR TRIVMPHO ·
QVEM PAREM SVMMIS DVCIBVS PERHENNIS ·
FAMA VIRTVTVM CELEBRAT DECENTER ·
SCEPTRA TENENTEM

QVE MODVM REBVS TENVIT SECVNDIS ·
CONIVGIS MAGNI DECORATA RERVM ·
LAVDE GESTARVM VOLITAT PER ORA ·
CVNCTA VIRORVM ·

Figure 32. Allegories on the reverse of the portraits of Federico da Montefeltro and Battista Sforza, Galleria degli Uffizi, Florence (figure 31)

Netherlandish painting, perhaps Jan van Eyck's now-lost picture of women emerging from their bath. That curious sounding work was owned by Ottaviano Ubaldini and was admired by the Humanist writer Bartolomeo Fazio for, among other things, its landscape—presumably seen through a window—of "horses, minute figures of men, mountains, groves, hamlets, and castles, carried out with such skill you would believe one was fifty miles distant from another."[87]

Then—at what interval it is difficult to say—there is what is unquestionably Piero's supreme achievement in architectural and perspectival design, the votive altarpiece now in the Pinacoteca di Brera in Milan (see figure 4). In that work, Federico, shown in full armor, kneels before the Virgin and her assembled court within the richly articulated space of a Renaissance church of distinctly Albertian design, giving painted form to that "grand style and the due measurement" Vespasiano admired in the Ducal Palace. Federico must have taken enormous pleasure in the way the actual scale of the church only becomes evident when, using the visual clues Piero provides, we mentally situate the court of the Virgin in its interior and realize the very considerable distance that lies between the figures assembled in the nave and the niche in the apse decorated with a delicately rendered clamshell. Piero here demonstrates how the mathematics of perspective can both resolve the problem of sacred figures becoming overwhelmed by the monumental building in which they are shown and also allow the architectural features seen in depth to reinforce the surface design of the composition. Light too plays its part, illuminating the figures while engulfing the apse in a meticulously mapped shadow that greatly enhances the effect of a volumetric space while also emphasizing the figure of the Virgin.[88]

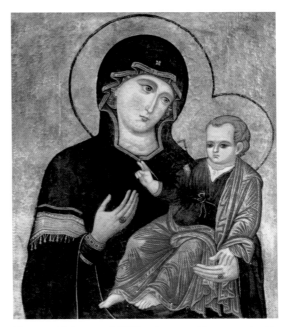

Figure 33. Madonna and Child, 13th century. Tempera and gold on wood, 44 × 37½ in. (111.8 × 95.3 cm). Santa Maria del Popolo, Rome

The culminating work of this association of Piero with the court of Urbino is the Madonna and Child from Senigallia, in which we move from the realm of public presentation, as exemplified in the Montefeltro Altarpiece, to that of private devotion. The ecclesiastical setting and ceremonial splendor so evident in the altarpiece are exchanged for an effect of domestic intimacy, while the studied attention to atmospheric effects found in the portrait diptych and the interest in directed lighting found in the altarpiece are transferred to the sunlit room in the background. Having set aside her regal brocaded robe and floor-length mantle, its hem embroidered with gold threads and pearls, the Virgin has donned a plain woolen dress that is laced up the front and has put a simple veil over her

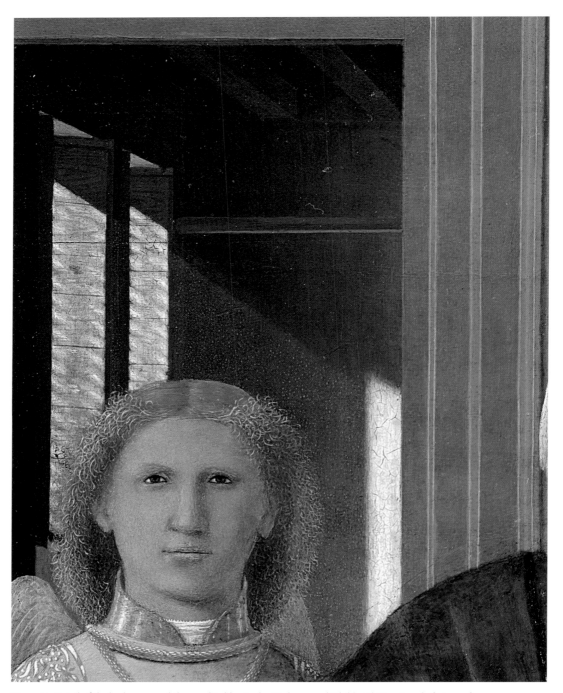

Figure 34. Detail of the back room and the angel in blue in the Madonna and Child with Two Angels (cat. no. 4)

pulled-back hair (only the ermine-lined mantle testifies to her exalted status). The painting has been dated very late in Piero's career, but the head of the Virgin may be traced from the same preparatory cartoon—flipped—that was created for the Montefeltro Altarpiece, and given what we know of commissions at the court of Urbino, the work is unlikely to date after 1474 and may even be somewhat earlier.

The picture has not always elicited the admiration conferred on it today. Although John Pope-Hennessy, in an essay of 1991, declared that "were we to play Huxley's futile game of naming the best pictures in the world, this little panel would certainly be on my list,"[89] the great nineteenth-century connoisseurs Joseph Archer Crowe and Giovanni Battista Cavalcaselle found the colors "leaden yet translucid" and the figure types ugly.[90] Even Kenneth Clark, an ardent admirer of Piero, felt it necessary to account for "the feeling of deadness which we experience in front of the original."[91] No one today, following its cleaning in 2010,[92] would agree with that assessment, but there is no question that the picture not only stands somewhat apart from Piero's work in general but that it also differs from most other devotional images of the time. In its own way, it is as unique as Mantegna's Madonna and Child in the Gemäldegalerie, Berlin. In that work, Mantegna dispensed with haloes or any other indication of the sacred status of the figures and imagined the Madonna as a mother worrying over the fate of her sleeping child. Piero too dispenses with haloes, but he then goes in the opposite direction, conferring on his mother and child the ritualistic gestures and hieratic austerity we might associate with an early Christian mosaic or a medieval icon. It is as though his intention was to recapture the sacred aura that attached to miraculous images such as the

Figure 35. Detail of the niche on the right in the Madonna and Child with Two Angels (cat. no. 4)

Madonna and Child in Santa Maria del Popolo in Rome, a work that Piero, like so many pilgrims in Rome, must have contemplated during his stay in the papal city in 1458–59, since it was among the works reputed to have been painted

by Saint Luke (figure 33).[93] We should not be surprised about this, for prior to 1470, Alessandro Sforza, the ruler of Pesaro, had a copy of this very image made by Melozzo da Forlì, and Cardinal Bessarion in Rome also had copies of early icons made by Antoniazzo Romano.[94]

There is about Piero's Virgin something of the austere dignity of a Madonna by Pietro Cavallini or by Giotto. Piero appropriated aspects of the Byzantine iconographic type known as the *hodegetria*—she who shows the way—to reinforce the effect of venerability. The Christ Child, his blanket draped like the toga on an ancient philosopher, is seated on the Virgin's left arm, his right hand raised in a gesture of blessing, his face directed to the viewer/worshiper. The coral necklace is a common talisman worn by babies of the time, while the rose this child holds identifies him not only as the Virgin's son but also as her betrothed (as an emblem of the Church, Mary was deemed the bride of Christ). Instead of pointing to him, as would be the case in a medieval image, the Virgin, with her gravely modest downcast gaze, touches his foot as a sign of respect.[95] Two angels stand guard, their rose and blue costumes suggesting their rank in the angelic hierarchy—a seraph and a cherub—and their jewelry and dress signifying their courtly status. With their ritualistic gestures and stern expressions, they might have stepped out of an early Christian mural or mosaic. Their arms are crossed in a conventional sign of homage, and their contrasting, somewhat forbidding gazes at once invite adoration and instill awe. The figures stand in the room of a Renaissance palace and behind them, seen through the door at the left, is what was surely intended to be understood as the Virgin's bedchamber (*thalamus virginis*), from which she has emerged to receive our supplications (figure 34).

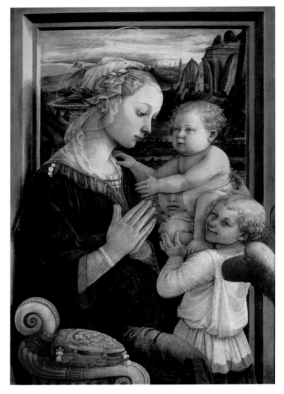

Figure 36. Fra Filippo Lippi, Madonna and Child with Two Angels, ca. 1465. Tempera on wood, 37⅜ × 24⅜ in. (95 × 62 cm). Galleria degli Uffizi, Florence

The doorframe and niche are placed asymmetrically, so that the head of the Madonna—aligned along the vertical axis—and that of her child are both silhouetted against an expanse of plain wall. In the niche are a basket of clean linen and a circular wooden box, common domestic objects but also items associated with the Virgin's work as a maiden in the Temple (figure 35).[96] The pilaster framing the niche is decorated with a flaming candelabra—an antiquarian motif that reappears in one of the copies of Piero's treatise on perspective and an emblem, perhaps, of the sacredness of the room; Piero leaves open the possibility of a such a meaning but does not

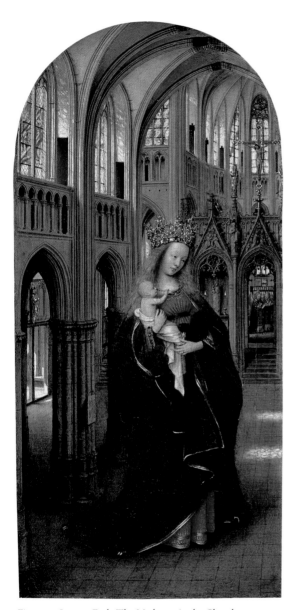

Figure 37. Jan van Eyck, The Madonna in the Church, ca. 1425. Oil on wood, 12¼ × 5½ in. (31 × 14 cm). Gemäldegalerie, Staatliche Museen zu Berlin

insist on it.[97] It would be difficult to imagine a painting further removed from the playful tenderness of a Florentine Madonna and Child by Fra Filippo Lippi (figure 36) or Luca della Robbia or the demure humanity of those by Giovanni Bellini, and one is reminded of an observation made by Sabba da Castiglione in the sixteenth century to the effect that Piero's use of perspective and his "secrets of art" made his work especially pleasing to intelligent viewers.[98]

Within the modest scope of a devotional image intended for display above a bed or perhaps in a private oratory, Piero presents us with an unsurpassed demonstration of his artistry. The viewer/supplicant is at once invited to a personal encounter and held in check at a decorous distance. That we are in the presence of the Mother of God is indicated not by the Virgin's apparel but by the gravitas of her demeanor and by the presence of the two vigilant angels. The one in blue seems with his implacable stare to guard the entrance into the sunlit back room, and it is in the narrow confines of that room — a place of privileged access — that Piero gives full scope to his lifelong interest in perspective, optics, and light. Without the beams of the ceiling, arranged longitudinally, and the foreshortened angle of the window embrasures, it would be impossible to diagram the perspective of the composition, the vanishing point of which is in the Virgin's right cheek, along the vertical axis.[99] And without the depiction of the diagonal shaft of sunlight filtered through the bottle-glass windows, picking out motes of dust hanging in the air and playing in dappled patterns on the window embrasure as well as forming a bright trapezoidal pool of light on the backmost wall, the work would lose that quality of actuality — of a sacred encounter in a real place and at a specific time of day.

55

It has been noted often that the closest analogy for this picture is found in a miraculous little painting by Jan van Eyck showing the Virgin standing in a diminutive Gothic church, with the sunlight piercing the clerestory windows and playing magically on the vaulting and pavement (figure 37) — an allusion, as has been shown, to a medieval hymn in which sunlight passing through glass is a metaphor for the miracle of the incarnation and the intact virginity of Mary.[100] Van Eyck is far from being the only artist to transform into a piece of extraordinary naturalistic observation what earlier painters had merely symbolized with gold rays. We might think, for example, of those depictions of the Annunciation by Filippo Lippi in which he includes in the foreground a still-life detail showing the effects of light passing through a water-filled glass vessel and the complementary effects of reflection and refraction (figure 38). In van Eyck's painting, not only do we see the effects of the sunlight piercing the window but we also see

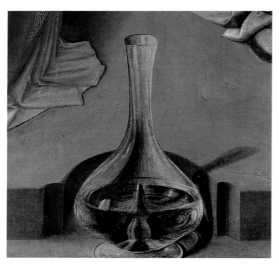

Figure 38. Fra Filippo Lippi, detail of vessel from The Annunciation, ca. 1440. Tempera on wood, 69 × 72 in. (175.3 × 183 cm). Martelli Chapel, San Lorenzo, Florence

the flying buttresses of the church *through* the window, which has the effect of elevating the metaphor to an emblem of the artist's powers of observation and his almost miraculous ability to counterfeit our experience of the real world. Piero cannot have seen van Eyck's painting of the Virgin in the church, but he was familiar with other works by the artist in the collection of Ottaviano Ubaldini, and as we have seen, he had closely studied Filippo Lippi's work in Florence in 1439. Moreover, he surely had heard of similar miracles of representation through the writings of court Humanists such as Bartolomeo Fazio, who describes a triptych by van Eyck belonging to King Alfonso of Aragon that included portraits of the two donors, and "between them, as if through a chink in the wall, falls a ray of sun that you would take to be real sunlight."[101] Italian painters were keenly aware of an ongoing and rather tedious criticism leveled by Humanist critics to the effect that words are better suited at describing the subtleties of nature than painting is. Piero, who meticulously drew the diagrams illustrating his mathematical treatises, knew better. Like van Eyck, he also understood that the suggestive power of a visual metaphor depends on the quality of description, which — as in a poetic composition — could be admired for its own sake, independently of what it alluded to. It is precisely such things that, as Alberti writes in *Della pittura* (III, 52), add to a painting's ability to "hold the eyes and minds of the viewer."

The Madonna and Child from Senigallia has struck many viewers (including Longhi) as an astonishing prelude to those scenes of domestic life in seventeenth-century Holland painted by Vermeer in which the poetry of light and the magic of geometry transform an everyday event or passing activity into a moment of exalted

Figure 39. Johannes Vermeer, Young Woman with a Water Pitcher, ca. 1662. Oil on canvas, 18 × 16 in. (45.7 × 40.6 cm). The Metropolitan Museum of Art, Marquand Collection, Gift of Henry G. Marquand, 1889 (89.15.21)

perception (figure 39). And certainly, there can be no question that, as in the work of the great Delft master, Piero employed a profound understanding of optics and the mathematics of perspective to achieve an effect of suspended time. Yet there is an important difference, and it has to do with Piero's understanding of painting as a demonstration of the science of optics at a time before science and religion had parted company. As a distinguished scholar has observed, "If in his reading Piero found the science of Optics placed at the service of a Christian cosmology, then it is entirely reasonable to suggest that in his picture[s], too, the magic of the behavior of light is a figure of the mystery of the revelation of the Light of the World, or of the presence of the divine."[102] It is Piero's manifestation of the immanence of God through the science of his art that makes the Madonna of Senigallia a fitting testament to his infrequent but always exalted engagement with the practice of devotional painting.

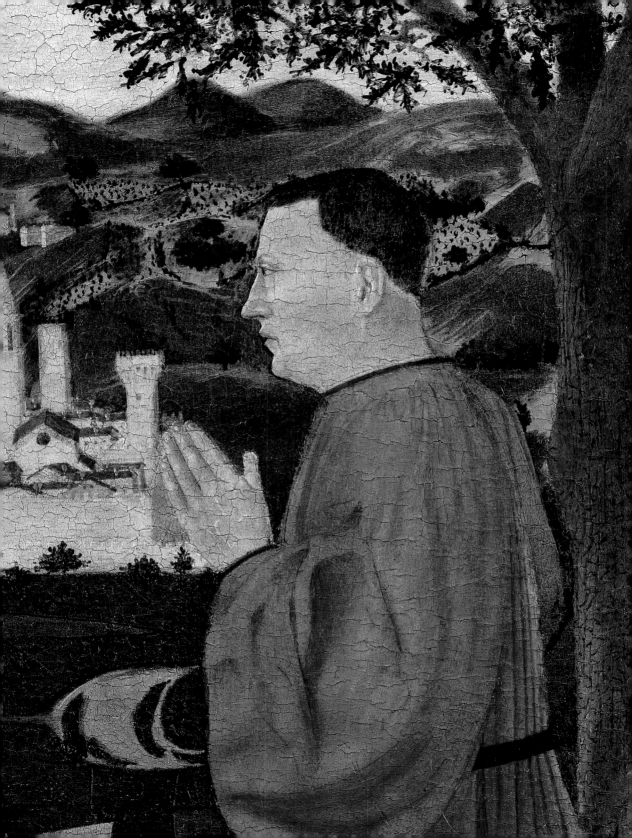

THE FAMILY OF GIROLAMO AMADI
A LUCCHESE SILK MERCHANT IN VENICE

BY ANNA PIZZATI

The presence of the Amadi family in Venice is documented as early as the beginning of the fourteenth century, with a Marco Amadi listed among those who lost merchandise on a Venetian galley captured by the Genoese off Corfu in 1303.[1] However, the Venetian scholar Emmanuele Antonio Cicogna refers to the family's participation in Venetian councils of the thirteenth century, before the constitutional provision of 1297 that set limits on membership of the Great Council (*Serrata del Maggior Consiglio*).[2] It is certainly true that starting in 1314, many Lucchese artisans who specialized in the silk industry were obliged to abandon Lucca and its surrounding subdivisions (*contado*) because of political conflicts that continued for several decades, and they settled in other cities, among them Venice. The Amadi arrived at the lagoon as part of this stream of migrants, bringing with them new capital and energy as well as experience in the field of dyeing and weaving silk, and perhaps being able to count on the support of other members of the family already active in Venice during the preceding decades.[3]

In the mid-1300s, the direct ancestors of Girolamo Amadi, the son of Agostino — the man presumably portrayed by Piero della Francesca in the Saint Jerome and a Supplicant (cat. no. 3) — were well-established on the island of Murano, where they owned a large palace (*chasa grande*), some smaller houses, furnaces, a mill, and some land, as well as properties in the area around Treviso. The oldest direct ancestor about whom we have secure documentation is Checco (Francesco) Amadi, who came from San Miniato al Tedesco, in the *contado* of Lucca. In 1350, he was a resident of the island of Murano, in the parish of Santo Stefano.[4] Both he and his brother Michele were dyers, and both were members of the confraternity of San Giovanni Battista in Murano.[5] His financial status was fairly solid and was strengthened by the goods he inherited from his first wife, Giacomina (*Iacopina* or *Iacomella*), who died during the year after the Black Death. Before the year after Giacomina's death had passed, Checco was remarried to Francesca, the daughter of Mondino da Salvarosa, from the territory of Castelfranco.[6]

In subsequent years, he is registered as having a taxable worth of 7000 lire, a considerable amount by the standards of the general economic situation in Venice.[7] In his will, Checco asked to be buried in Santa Maria dei Servi, the principal church of the Lucchese community, where a nephew of his, bearing the same name, was a friar. Murano was the location of the Amadi factory, where silk skeins were dyed before being woven. In 1350, when Checco made

his will, their organization appears to have been solidly grounded, even if he was concerned about the fate of the family business after his death, because of the conflicts that might arise between his brother Michele and his son Giovanni, who was his sole heir and still very young. To protect his son's interests, Checco disposed that Michele could work in the company on condition that there was an equitable sharing of both profits and expenses, with respect to the initial capital. A bookkeeper was to be employed at the company's expense to ensure that the executors could keep track of its accounts. Only on these conditions could Michele work in partnership (*compagnia*) with his nephew, "and, Checco concluded, if he did not wish to do so, that was his business" (*et se non volese fare così si fatia i fati suoi*), because in that case it was better to lease the business to outsiders. As it turned out, when Checco died (between 1359 and 1369), Giovanni had reached legal age, but his financial situation was somewhat weakened, partly because of the economic downturn of the two decades following the Black Death.

In 1369, Giovanni Amadi petitioned for a reduction of the taxable income used to calculate the forced loan formerly paid by his father, Checco (7000 *lire a grossi*), which had now become so untenable that he was behind in his payments.[8] The economic difficulties caused by his father's death were aggravated by the fact that he had five very young children. In order to tackle his family's financial crisis, Giovanni—a citizen of Venice who had loyally fought in the war against Trieste in the preceding year—"was compelled, notwithstanding his profession as dyer, to work in the profession of glass-making" (*reducere se ad faciendum artem vitreariorum*). Before fiscal amnesty was granted, the mayor (*podestà*) of Murano and the *Ufficiali al Cattaver*, who had

authority in such matters, were consulted. Giovanni Amadi was indeed a debtor, but thanks to his father's inheritance, he had good income from some houses, several pieces of land, a mill for grinding linen, and a furnace, and he lived in a house in Murano with fine furnishings (*habet optima mobilia in domo sua*). Bearing this in mind, the officials concluded that "if those who have possessions but scarcely any cash flow were to be exempted, the majority of Venice's citizens would be excluded from forced loans" (*si illi qui habent possessiones et non habent dinarios deberent esse exempti ab imprestitis maior pars civium Veneciarum non faceret imprestita*). Giovanni succeeded in obtaining a reduction of the taxable amount from 7000 to 2000 lire and the cancellation of the penalty for nonpayment. Some years later, when the records of 1379–80 were made, we find him registered with a taxable worth of 1000 lire, while the figure for his uncle Michele is given as 3500 lire.[9]

The document of 1369 reveals a flourishing financial situation, even if it had declined since the preceding generation. The same document also tells us about Giovanni's five young children, the oldest aged seven, and this piece of information allows us to narrow down the birth dates of Francesco and Amato, two of Giovanni's sons, who were to bring the family to a remarkable level of grandeur, between 1362 and 1369. But the Amadi were already in a prestigious position during the last two decades of the 1300s, to judge by the presence of the family coat of arms on an altarcloth in the church of Santo Stefano in Murano, the parish to which they had belonged when they first arrived in the lagoon.[10] After Giovanni's death in 1382, the two young brothers would find themselves running the family business.[11]

The genealogy reconstructed thus far differs notably from what we are told by sources such as

the *Cronaca Amadi*, the *Cathalogus illustrium virorum*, and the *Venete famiglie cittadinesche*, especially regarding Giovanni, who is reported to have married the patrician Giulia Zen, and after having fathered ten children, to have abandoned lay life for an extraordinary ecclesiastical career, first becoming Bishop of Venice and then Cardinal. Archival research calls for caution here, not only with respect to the unlikely story of his conversion and ascent to the summit of the Church but also about his marriage and offspring.[12] Of the five children declared in the document of 1369, we know about four: Francesco and Amato, about whom we shall speak further; Giorgio, who lived in the shadow of his two more entrepreneurial brothers;[13] and Perina (or Pierina), who also played an important part of the family enterprise since she was married to Lorenzo de Provenzali (*de Provincialibus*), a business partner of Francesco and Amato. By 1405, widowed with three children, she lived in the house in San Canciano she had inherited from her husband, probably a point of reference for her brothers Francesco and Amato when they left Murano, and subsequently a base for some members of the Amadi family who went to live with her.[14]

FRANCESCO AND AMATO, CITIZENS AND MERCHANTS IN VENICE

Francesco and Amato soon abandoned their father's specialized place in the dyeing industry, broadening their activity as citizens and merchants (*cives et mercatores*) in Venice. Business ties and friendship with the Kress family, important merchants from Nuremberg already established in the 1390s (as we know from documents), reflect just one part of their commerce with the German world, marked by export of silk cloth and spices, and import of precious metals. The very high profits achieved by the two brothers during these decades were the result of an excellent communications network and a precise and up-to-the-minute knowledge of the market and its continuous fluctuations. Two letters of 1392 sent by Amato to his brother Francesco care of the Kress in Nuremberg are a small token of the wealth of information transmitted on a daily basis, which enabled them to make good investments.[15]

In the years that straddled the new century, the two brothers, referred to as Amadi "of the silk trade" (*dalla seta,* or *a serico,* in Latin) were great travelers, both in Northern Europe and the Levant, and their workshop at San Bartolomeo was entrusted to partners with union contracts that allowed for strict business controls.[16] Francesco was clearly at ease in an international context; in March 1406, he was sent on a diplomatic mission as representative of the Venetian Republic to Frederick IV, Duke of Austria and Count of Tyrol, and to the Bishop of Trent, to sound them out for a possible alliance and in order to favor the opening of the important commercial route of the Brenner Pass.[17]

The two brothers had an enduringly strong relationship with secular and religious bodies linked to the Lucchese community, such as the Scuola del Volto Santo (of which Francesco was elected rector in 1400 and 1411) and the church of Santa Maria dei Servi. Their coat of arms was displayed in the Corte della Seta, together with those of other families of Lucchese origin who belonged to the silk-workers' corporation, such as the Paruta, the Sandei, the Ridolfi, and the Perducci. But the Amadi also belonged to other institutions, such as the Ospedale dei Santi Pietro e Paolo, of which Francesco became *procuratore* in 1400, and the Scuola Grande di San

Giovanni Evangelista, of which both men were members.[18] A privileged connection was established between the brothers and two other religious bodies in the lagoon, the Camaldolese community of San Michele in Isola, where Francesco asked to be buried, and the Benedictine monastery of Sant'Andrea della Certosa, which is mentioned in his will as the recipient of a fifty-ducat bequest. Moreover, they financed some works in the Certosa di San Girolamo del Montello and gave shelter to the Carthusian monks in 1411, when Sigismund of Hungary's army was invading the territory around Treviso and the monks found refuge in the Lagoon, in the Amadi properties in Santo Stefano di Murano.[19] These were the same houses Giovanni, the son of Checco, had left to his sons. They remained in undivided ownership until 1419 and only then they were split into four shares, one each for Francesco, Amato, Giorgio, and Perina.[20]

Before the end of the 1300s, the two brothers left Murano for Venice, in the nerve center of the city's mercantile activity, a few steps from Rialto and close to San Marco. Their newfound wealth enabled them to acquire two prestigious principal residences (case dominicali) in which they could live with their sizable families. Francesco was the first to move, settling in the last years of the century in the large house (casa da stazio) in the contrada of Santa Marina, very close to where the church of Santa Maria dei Miracoli was to be built at the behest of his great-grandchildren, and where one can still see the fine doorway to the courtyard, with the family coat of arms.[21] Here Francesco went to live with his wife, Orsa, and his sons, Giovanni (the eldest), Domenico, Amato, Lorenzo, and Alvise, and daughters, Bonaventura, Taddea, Graziosa, and Modesta. A tutor was responsible for their education, in which technical skills appropriate to

commerce were balanced by the humanities (studia humanitatis) and the study of languages. During the first decade of the new century, Francesco Amadi commissioned a devotional image from Nicolò di Pietro, a painter with a well-known workshop in the city, and he approached Gentile da Fabriano, an artist who was foreign to Venice but was already greatly renowned, although he had not yet been summoned to paint frescoes in the Sala del Maggior Consiglio in the Doge's Palace.

Some years later, the brothers Francesco and Amato bought another grand casa dominicale, in an even more strategic position in the parish of San Giovanni Crisostomo, close to the silk-workers' confraternity, where other Lucchese families lived, and above all, only steps away from the Fontego dei Tedeschi (figure 1). This house with a courtyard, which became the residence of Amato and his descendants, is still extant, and its attractive main facade overlooks the Rio dell'Olio (the canal flowing toward the Grand Canal), on the side opposite the Fontego dei Tedeschi. How the large house with a courtyard (domus magna a statio) in San Giovanni Crisostomo was purchased is noteworthy. On January 2, 1406, at death's door, Giovanni Troncon named his son Zanino as sole heir, with a bequest to his other son, Giorgio, who had disobeyed his father's wishes, of the interest on 1000 ducats of forced loans, with a clause stating that were he to reform himself, he could lay claim to a quarter of the inheritance. Zanino and Francesco Amadi were executors and thus were empowered to decide if Giorgio had mended his ways.[22] In September of the same year, the two executors sold the large Troncon house to Orsa, the wife of Francesco Amadi, who sold it to the two Amadi brothers one month later.[23] We do not know to what extent Zanino

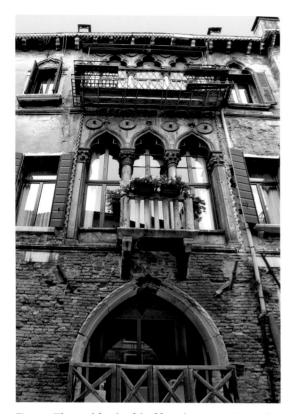

Figure 1. The canal facade of the fifteenth-century Ca' Amadi, as seen today, Venice. Photograph by Paola Baldari

addition of two other significant pieces of domestic real estate to the *case dominicali* in Santa Marina and San Giovanni Crisostomo, the first located in the same area of San Canciano, in *Biri Piccolo*,[26] the other, a *casa dominicale* later celebrated by Francesco Sansovino, in another part of the city, near the church of the Tolentini in the *sestiere* of Santa Croce.[27]

Toward the end of 1406, Amato took up residence with his large family in the new house in San Giovanni Crisostomo. He had at least eight children, mostly by his first wife, Agnesina, who died in the early months of 1409.[28] Amato was remarried within a few months to Gasparina, the widow of Zanino Troncon, with a dowry of 1500 ducats.[29] When he died (between June 1422 and February 1424), some of his children were still under twenty. Among these, certainly, was Agostino, born toward the end of 1410, the youngest son and the only one we are sure was a child of Gasparina's.[30] Amato ordered that the inheritance should remain intact until all the children had reached the age of twenty, and he managed the estate under the direction of his brother Francesco, who was appointed to supervise the activities of the children and had the authority, if necessary, to put a hold on the family goods to safeguard the interest of all concerned.[31]

Between 1422 and 1425, death came to Francesco, Amato, and even Amato's firstborn, who bore the same name as his adored brother. The responsibility of managing Amato's estate was taken on not only by his sons (those aged over twenty) but also by Giovanni, the oldest son of Francesco; later, the obligation passed on to the *procuratori* of Saint Mark's. Acting in perfect agreement, as is reflected in their wills, the brothers Francesco and Amato endowed their family with wealth and prestige, and they used the politics of marriage to strengthen their ties

Troncon was free to agree to the sale of his father's fine house, and indeed, he reaffirmed his trust in Francesco Amadi, naming him as his executor together with two other individuals.[24] In 1413, a few months after Zanino's death, his widow, Gasparina—with one son in her charge—married Amato Amadi, who had also lost his first spouse.[25] This is a good example of the web that linked business interests and family connections, in which the two Amadi brothers had the lion's share of the action.

The Amadi's property expansion in Venice continued briskly during the early decades of the 1400s. The first half of the century saw the

AMADI

Figure 2. Genealogical chart of the Amadi family, compiled by Anna Pizzati with the help of Alba Scapin

with the patriciate. One need only look at the family genealogical chart (figure 2) to see the results of this strategy, with the evidence of the unions of their sons and daughters with the Morosini, Tron, Pisani, Molin, Barbarigo, Bon, Grimani, Nadal, and Nani families.[32] In addition to significant property and prestige, the younger generations inherited a refined sensitivity to art and culture from Francesco and Amato, which explains how the Amadi were patrons of such exalted artists as Gentile da Fabriano, Piero della Francesca, Pietro Lombardo, and his sons Tullio and Antonio, not to mention their fine taste in collecting during the mid-1500s.

THE INHERITANCE OF AMATO AMADI

In December 1424, an inventory was made of the goods in Amato's house in San Giovanni Crisostomo, a luxurious residence where images of Marian devotion and a Saint Jerome alternated with precious fabrics and goldsmiths' work and furnishings from different parts of the known world—the German nations, the Levant, and Flanders. Common items of clothing coexisted with what would have been useful to wear on the long journeys by galley that often took these merchants far from Venice, or special items such as two garments—*pelande gardinalesche*, a name that evokes the robe worn by the supplicant kneeling before Saint Jerome in the painting by Piero. This association may not be so far from the truth if the sitter was indeed Girolamo, son of Agostino di Amato, and thus the grandson of the owner of these *pelande gardinalesche*.[33]

The surviving heirs to the family business left by Amato were Girolamo, Benedetto, and Agostino. Perhaps Benedetto's lack of business acumen led to his father's lack of trust. While Amato left him a share of the inheritance equaling those of his siblings, he made it legally binding that this should be invested in forced loans (*imprestiti*), so that no one could touch the capital after his death, except his heirs, and that he could profit from the interests for life.[34] Amato's business heirs thus were Girolamo and Agostino. The latter struggled to express how much he could claim of his father's legacy. In 1429, when he was still a ward of the estate, and complaining about the inequitable treatment with respect to Girolamo, Agostino had succeeded in having his annual income increased.[35] In 1436, the *procuratori* of Saint Mark's intervened against Girolamo, who had taken possession of silk clothing, silver, jewels, and numerous paintings, including a large gilded altarpiece (*una ancona granda dorata*)—goods amounting to nearly 1000 ducats.[36]

Documents provide abundant references to Francesco and Amato, offering a profile of their extensive mercantile activity, of how they took root in the city through the purchase of substantial residences, how their prestige enabled them to receive diplomatic appointments from the Republic, how they held office in some of the top institutions that Venice reserved for its citizens, and last but not least, of their cultural involvement through the commission of works of art for public and private devotion from celebrated artists. In the next generation, it was above all the many sons of Francesco who played a dominant role, reaching their zenith in 1480, when they succeeded in organizing a general devotion around two miraculous images in their possession. As catalysts within the parishes of Santa Marina and San Lio, the Amadi succeeded through both popular and patrician support in encouraging the foundation of two churches associated with Marian veneration,

Santa Maria dei Miracoli and Santa Maria della Consolazione alla Fava.[37] The choice of an architect to build the church of the Miracoli fell to Pietro Lombardo, precisely because he was highly regarded, and, as Angelo Amadi recalls in the *Cronaca Amadi*, he had recently erected the celebrated funerary monument to Doge Pietro Mocenigo in the Venetian church of Santi Giovanni e Paolo.[38]

AGOSTINO, SON OF AMATO

Regarding Agostino, the youngest of Amato's sons, we may hypothesize that he spent his younger years running the family enterprises that had made the fortunes of his father and his uncle Francesco and that he must have had to learn the ropes quickly, without being able to count on his father's support (Amato had died when Agostino was thirteen or fourteen) or on that of his brother Girolamo, with whom there was little mutual understanding. Agostino stayed in the house in San Giovanni Crisostomo, and he inherited the shares of his sister Polissena and his brother Francesco.[39] Born about 1410, he could only have married after 1430, because until that point, he was legally and financially dependent on the family estate. The *Cronaca Amadi* has him fighting on the battlefields of Milan against Filippo Maria Visconti in 1426, but we can be certain of the information cited by Cicogna regarding his marriage to Pellegrina Piscina (or Pescina), from a family of Milanese origin related to the Loredan.[40] Agostino had five sons and one daughter (Francesco, Pietro, Girolamo—the candidate for the supplicant in Piero's painting—Filippo, Ziliveto, and Fontana), and we may consider 1431 as the earliest limit for the birth of his first son Francesco.[41] Francesco

died between December 1459, the year he took part in the *probae*, a process of submitting names for the assignment of public office, and November 1464, when his wife Pellegrina is recorded as a widow.[42]

GIROLAMO AND HIS BROTHERS

It appears that Agostino's sons had a revived sense of belonging to an extended family, or *casa*, and of the need to take a united stand: their family strategy would bind them all, whether it was for managing a commercial business, contracting a marriage, building a villa on the *terraferma*, creating a family chapel, or becoming members of a confraternity. In the generation after Agostino, there also seemed to be a closing of the ranks among the families of Lucchese origin, who were now in a state of crisis after the successes and great accumulations of wealth of the period between the mid-1300s and mid-1400s.[43] The foundation of the church of the Miracoli, in 1480, was something that bound the entire *casa* Amadi together, because while those behind it were the descendants of Francesco the Elder, and the events took place very near the *casa dominicale* in Santa Marina, the *Cronaca Amadi* narrates that Amato's descendants also played an active role and were part of the procession for the laying of the first stone.[44]

Of the five sons of Agostino, a special bond united Francesco, Pietro, and Girolamo, who were also connected through their marriages to several sisters. Let us see if we can find a path through this genealogical maze. Francesco and Pietro had married the Da Ponte sisters, respectively Paola (known as Pasqualina) and Cecilia, daughters of Bernardo Da Ponte.[45] In their second marriages, Pietro and Girolamo were

wedded to Lucrezia and Elisabetta, daughters of Giovanni Ridolfi, a family of Lucchese origin.[46] Francesco must have been the oldest child, as he was a constant point of reference for his siblings. He also enjoyed public prestige, since in April 1475, he was sent by the Republic of Venice to Tuscany, charged with enlisting anyone willing to join a naval expedition against the Ottoman Turks.[47] In 1503, Francesco expressed his wish to be buried in the church of San Giovanni Crisostomo, in the chapel "to be completed by all of us brothers" (*se die compir per tuti nui fradelli*), to which he left 100 ducats, inviting his brothers to contribute their share and involve themselves in the family project. Not having any legitimate children, he named his brothers Girolamo and Pietro and his nephew Agostino (Pietro's son) as executors and heirs with three equal shares. Girolamo's death induced Francesco to modify the bequests in his will in June 1507, so that Girolamo's son Domenico would now inherit a third of his estate. It is precisely from this codicil, and from that made by Francesco's wife, Paola, that we can deduce when Girolamo Amadi, the son of Agostino, died, probably in the early months of 1507.[48]

In his will, Francesco also remembered the two other brothers — Ziliveto, who had no direct heirs and would receive fifty ducats, and Filippo, involved by his older brother in the inheritance, but only conditionally, as repeated several times in a puzzling clause. Filippo could even have become his sole heir, but only if "he had legitimate male children, and from a good marriage, and not otherwise" (*fioli mascoli legiptimi et de bon matrimonio et non altramente*). At the time of Francesco's will in 1503, Filippo had been a widower for a few years and already had four legitimate children, two of whom were sons. We may deduce that Francesco did not consider Filippo's union a *bon matrimonio*. Filippo had married Elena (her real name was Cateruzza), daughter of Giacomo Rompiasio, with a relatively modest dowry; Elena's potential future legacy would amount to 550 ducats. The Rompiasio were a merchant family from the Giudecca, and Luca Pacioli had been their tutor in the 1470s, teaching the children of Antonio.[49] We know this from Pacioli himself, and he speaks of how he frequented the Scuola di Rialto in the period he lived in the Rompiasio home in the Giudecca and during the years that followed, when he continued to visit Venice to supervise the publication of his writings. We do not know how Elena was related to Antonio Rompiasio, but she was certainly a member of the Giudecca Rompiasios. Filippo married Elena in the 1480s, and in 1490, she already had three small children, Giovanni, Laura, and Giulia, while the fourth child, Alessandro, was born in 1494. Laura was married in 1498 to Benedetto Arborsani, a man of Lucchese origin who was the author of another of those very rare family chronicles written in Venice.[50]

The Amadi frequented the Rompiasio house and may have had occasion to make Luca Pacioli's acquaintance in the years he was a guest on the Giudecca. And it may be that it was the Franciscan friar, an acquaintance of Piero della Francesca's and a fellow citizen of Borgo Sansepolcro, who provided a connection with Girolamo Amadi. In any event, Filippo's marriage to Elena Rompiasio changed his relationship with his brothers. Evidence of this break comes not so much from the wills drawn up by Filippo in 1490, as he was leaving for Alexandria, or four years later, when he was about to travel to Constantinople. In fact, the heartfelt entreaties he made to his brothers to look after his children and his wife, Elena Rompiasio, in the event of his death would seem to show the opposite.[51] Yet such a rupture

Figure 3. The Amadi coat of arms decorating the portal to the courtyard of Ca' Amadi, Venice. Photograph by Frank Dabell

Spanish letter of safe conduct of the 1460s or 1470s relating to their shipments in Valencia, and a document of February 1494 about the sequestering of one of their ships, the *Santa María degli Angeli*, confiscated by the Republic in the port of Modone (now Methoni, Greece) in order to be armed and sent with the Venetian fleet to Corfu. Furthermore, we get a glimpse of Francesco, Pietro, and Girolamo's business accounting from an inventory referring to two volumes, the *Libro crose* (469 folios, covering the period 1479–1500) and the *Libro A* (143 folios, 1500–1510), and there were also the *Libri di Terraferma* relating to the administration of their land. From the fourteenth century onward, the family's commercial profits had been invested in property in Venice, in the purchase of *case dominicali* and other city properties, and initially, in the area around Treviso. With the conquest of Padua at the beginning of the 1400s and the consolidation of Venetian power on the mainland, part of the Amadi's financial resources were used for the acquisition of real estate in Padua and its *contado*. During the 1480s, Francesco, Pietro, and Girolamo intensified their purchases in view of an ambitious project, the construction of a villa in Padua, close to the city walls outside the Porta San Giovanni.[53] In 1497, the group of buildings, which consisted of the villa and many other smaller houses, was completed. It must have been a prestigious ensemble if Marino Sanudo later stated that Cardinal Giuliano Della Rovere intended to rent the Paduan house of the Amadi, outside the Porta San Giovanni. This reference turns out to be groundless, but the fact that it was mentioned is significant.[54] However, this grand project, in which the Amadi invested so much of their capital, was to have a sorry end. With the occupation of Padua and its *contado* by Imperial troops in May and June 1509, as a

may be deduced from the will of Francesco Amadi and from the fact that while Francesco, Pietro, and Girolamo continued to work together on a long series of property deals, with the purchase of land in Padua and its surrounding area, Filippo was not involved. In 1515, his sons Giovanni and Alessandro began a lawsuit against their cousins, making claims to the inheritance of their uncle Francesco. Defending themselves, Agostino (son of Pietro) and Domenico (son of Girolamo) said it was scandalous that the Amadi should fight one another, contravening their ancestor's wishes, but the disagreement clearly proves that indeed Filippo's children had been excluded from the inheritance because they were not the issue of a *bon matrimonio*.[52]

The *Cronaca Amadi* provides indirect evidence about the Amadi brothers as merchants: a

consequence of the League of Cambrai, the great *casa da stazio* by Porta San Giovanni was completely destroyed. In Marino Sanudo's words, on June 5 of that terrible year, "In Padua . . .many houses of gentlemen were sacked, and certain ones were almost ruined, such as that of the Amai, outside Saint John's Gate" (*Di Padoa . . . fo messo a sacho molte caxe di zentilomini e citadini et tal quasi ruinate, zoè quella di Amai, fuora la porta di San Zuane*).[55] Other sources tell us that the Amadi houses in Padua, including the *casa dominicale*, were not destroyed by the enemy but were "flattened" on the orders of the Republic, which, in order to deal with the assault on Padua by the Cambrai alliance, had them razed to the ground to fortify the city walls and the Palazzo del Podestà with the resulting material. The episode must have weighed heavily on the Amadi, and it endured in the family's memory.[56]

GIROLAMO'S MARRIAGES

The first wife of Girolamo was Elisabetta Tedaldini, whose handwritten note to her will of December 1490 betrays her terror before the imminent birth of a child, probably her first;[57] she did not survive the much-feared event. This much can be deduced from the fact that the newborn daughter was named after her and that soon thereafter, Girolamo married Elisabetta Ridolfi. Girolamo's marriage to Elisabetta Tedaldini appears to have been a late one, somewhere around 1489, and probably decided upon as an urgent family strategy to guarantee descendants for this branch of the Amadi family: of his brothers, Pietro had only had one son, Francesco and Ziliveto were childless, and Filippo's children were excluded because of the "bad" marriage. Girolamo Amadi himself had four children, the oldest, Elisabetta, by his first (Tedaldini) wife,[58] and Elena, Modesta, and Domenico by his union with Elisabetta Ridolfi.[59]

Between 1507 and 1513, the three brothers Francesco, Pietro, and Girolamo all died, as did their other brother, Ziliveto.[60] The beneficiary of most of the estate was Pietro's only son Agostino, but part of the inheritance went to Girolamo's children Domenico, Elena, and Modesta.[61] Apart from the now-devastated properties in Padua and its surrounding territory, Girolamo's sons declared in their 1514 tax return that they had income from a *bottega* in San Bartolomeo that had come with the 1489 dowry of Elisabetta Tedaldini.[62]

Domenico, Girolamo's only son, died young in 1519, leaving as sole heir his unmarried sister Elena. To Modesta he left only fifty ducats, because her wish to join the convent of Sant'Alvise (*elegit viam Dei*) meant that her inheritance was more than sufficient for a nun.[63]

Thus, Girolamo's entire inheritance went to Elena, and this wealth enabled her to contract two good marriages, the first to Girolamo di Alessandro Marcello and the second, in 1539, to Leonardo di Giacomo Da Mula from the *contrada* of San Boldo. Elena died childless in April 1554, and Da Mula was her principal heir. The posthumous inventory of her goods contains a list of numerous family notarial deeds and account books that had come down to her after the division of goods with her cousin Agostino, Pietro's only son. Reference is made to various wills, but not to that of her father, Girolamo, who probably died intestate.[64]

THE DESCENDANTS

On the death of Domenico, who was childless, the descendants of Amato Amadi's branch of

the family continued along one line through the children of Filippo and of Elena Rompiasio, and on another through Agostino, the son of Pietro Amadi and Cecilia Da Ponte.[65] Filippo's sons Giovanni and Alessandro made their fortune in Padua, where they had moved after Giovanni's marriage to a wealthy Paduan woman. In 1523, the official delegation sent by the city of Padua for Andrea Gritti's election as Doge was composed of four orators, and their retinue included some "rich young men . . .dressed in gold, with chains" (*zoveni et richi . . .vestiti d'oro con cadene*), one of them being Filippo's son Giovanni Amadi, "a Venetian citizen, who has married in Padua and been made a citizen there" (*citadin veneto, qual si ha maridato a Padoa e fato citadin di Padoa*), and who on this occasion was knighted by the Doge.[66] They too died out in two generations. The last descendant, Adriano, who had no male issue, did his utmost to preserve the memory of his family, disposing that after his death and that of his wife, Cristina Veruzzi, the real estate and assets, the gallery of portraits he owned, the library, and all the family papers should go by inheritance to the eldest son of his Venetian cousin Pietro, who was the only living descendant of Amato the Elder. In order to pass the Amadi name on to posterity, this heir was bound by the will to move to Padua, in the palazzo near the Prato della Valle, and become a Paduan noble.[67]

In Venice, the bulk of the uncles' inheritance — the numerous properties around Padua and some houses in San Giobbe, where two Amadi coats of arms are still visible — passed to Agostino, the only son of Pietro.[68] Thanks to what he inherited from his uncle Ziliveto, he became owner of the Amadi buildings in Santa Croce, near the Tolentini, where the Calle degli Amai still runs today, and where the family arms (figure 3) can be seen on one house.[69] Here, he moved

with his wife, Giovanna Brocardo (daughter of Marino, a renowned Venetian physician, and sister of the Humanist Antonio Brocardo), and their two children, Francesco and Marina. It was above all through the efforts of Francesco that the palazzo was restructured a few years after the middle of the century, and it became famous for its magnificent garden with a wealth of rare cultivated medicinal herbs and for its interiors with remarkable and eclectic collections of books, mathematical instruments, antiquities, ancient coins, and sculptures and paintings. Francesco owned works by Giovanni Bellini, Titian, Giorgione, Pordenone, Raphael, and Michelangelo.[70] He was a jurist, *letterato,* and academic associated with the literary circles of the Trissino academy, strongly influenced by the "anti-Bembo" stance of his uncle Antonio Brocardo and celebrated among his contemporaries for both his collecting and his writings (Cardinal Pietro Bembo was a scholar and theorist who promoted Tuscan as the model for Italian).[71] His passion for the antique led him while still very young (1535) to continue the *Cronaca Amadi* begun by Angelo, but while Angelo gave a detailed account of the events leading to the foundation of the church of Santa Maria dei Miracoli, Francesco's concern was to "gather" documents on his ancestors and "devise" a collective memory for the family. The text is highly unusual in a Venetian context, in which the production of family histories is rare. The Amadi were citizens, and the chronicle was written by Francesco during the 1530s, when the Venetian government was seeking to define and establish the category of native citizen, which was until then only generically defined. In a moment that was less than felicitous with regard to both demographics and economy, compared to the level of splendor they had reached in the

preceding century, the Amadi family felt the need to celebrate a greatness that had indeed been real but that in Francesco's reconstruction, is partly fanciful.[72]

Francesco had one son by his wife Faustina Marin, Agostino, who inherited the precious collections and the large house at the Tolentini. On his mother's death in 1584, Agostino inherited part of the estate that had guaranteed her dowry (valued at 1600 ducats) and was now available. Among the goods were a number of books on medicine and jurisprudence, marble and bronze statues, musical instruments, and a large number of paintings, including a gallery of seventy-three portraits.[73] Agostino reached the highest echelon of a career in the chancery, becoming secretary of the Consiglio dei Dieci, and it was while he held this office that he wrote his *Libro delle cifre,* a treatise on ancient and modern secret writings.[74] But the family's finances were shaky, and on his death in 1588, in exchange for the immediate consignment of the "seven volumes of ciphers" (*sette volumi di ziffre*) to the Consiglio dei Dieci, they received a monthly pension of ten ducats "for the sustenance of his poor family" (*per sustentatione della sua povera famiglia*) as well as the possibility for two sons to enter the Cancelleria without having to undergo an initial selection process.[75]

Taking advantage of this, Agostino's son Pietro became a notary to the Cancelleria Ducale, and although his career had only just begun, he applied himself between 1594 and 1596 to the long laborious transfer of the Grimani bequest to the Statuario della Repubblica, earning the praise of the procurator of Saint Mark's, Federico Contarini.[76] In his father's wake, Pietro dedicated himself to cyphered messages.

In 1597, he presented a finely composed official request to the Senate, which charted the glorious history of his ancestors, who had "dispersed [their] goods and shed [their] blood for the benefit of the Serene Republic" (*speso la robba et sparso il sangue a beneficio di questa Serenissima Repubblica*), "through the fiscal contributions and wealth brought to patrician families by the dowries of the Amadi women." He also recalled an illustrious past that saw members of his family sent by the Republic of Venice on diplomatic missions.[77] Pietro took great care to cite only episodes that could be documented, or were at least plausible, without resorting to the fable-like narrative of the three sources cited in the paragraph preceding the notes to this essay. According to this trio of manuscripts, the Amadi came from Bavaria, and counted among their ancestors no less than three cardinals, seven bishops, counts, knights, and a host of other notable individuals. This family "history" was created through words and also brought to life through images, with the commission of a gallery of portraits, as we can tell from the items listed in a mid-seventeenth-century inventory, in which figures from the Amadi "mythology" stand side by side with members of the family who actually had existed.[78]

Pietro had no sons, and in 1650, Amato the Elder's line had become extinct. Adriano's inheritance, according to his wishes, was assigned to a noble Paduan family, drawn by lot from among those who had fallen on hard times, the Dondi dall'Orologio. Together with this legacy, they would have had to take on the Amadi name: "it being my aim that the Amadi family name should live on as long as possible, among the nobility of Padua" (*essendo mio fine che viva sì il cognome Amadi più che sia possibile et citadino de conseggio de Padova*).[79]

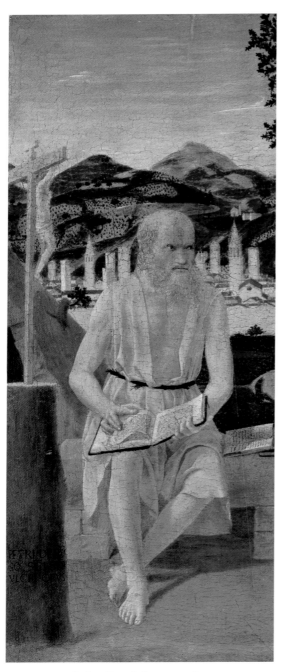

Saint Jerome and a Supplicant before restoration

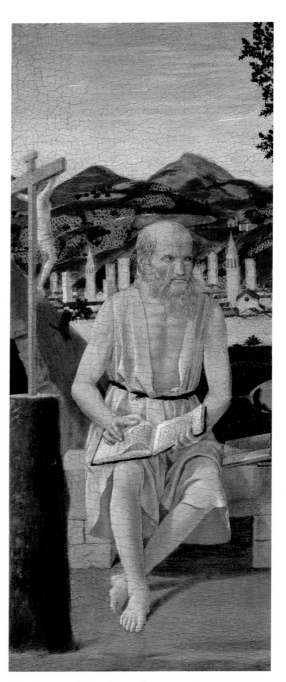

Saint Jerome and a Supplicant after restoration

The Restoration and Technical Examination of Saint Jerome and a Supplicant

by Roberto Bellucci, Cecilia Frosinini, and Chiara Rossi Scarzanella

1. Notes on the technique, condition and Conservation

by Chiara Rossi Scarzanella

The conservation treatment of this painting proved to be particularly stimulating and resulted in new information regarding its execution and condition. The picture was more damaged than initially anticipated, and the work consequently had to be that much more exacting. But the aesthetic gains have also been more substantial than one would have thought. Special focus is given here to those aspects that may interest readers who are not in the field of conservation; a more detailed technical discussion will be published by the OPD.

It was immediately apparent that the painting's dimensions (19½ × 16½ in. [49.4 × 42 cm]; painted surface of 19½ × 15½ inches [49.4 × 39.5 cm]) had been reduced; the poplar-wood support having been trimmed around its entire perimeter. On the left and right sides, only a small part of the bare wood, originally covered by the frame, had been removed, without encroaching on the paint surface, which retains its original raised (or barbed) edge. Along the lower edge of the panel, this cropping also affected the picture surface, which was reduced by an unquantifiable but no doubt modest amount. The reduction of the panel along its upper edge may have been more significant: to judge from the traces of where nails used to attach the frame were inserted, as much as 3¼ to 3½ inches (8 to 9 cm) of the picture surface may have been lost. The painting's format thus originally would have been more rectangular, and the composition may have included the entire foliage of the oak tree, giving greater verticality to the composition but also resulting in what would be admittedly unusual proportions if the picture is compared to other devotional paintings by Piero.

The tonality of the painting had darkened and yellowed since under its more recently applied varnishes, there was a thick yellowish coat of varnish containing egg yolk and glazes datable to its restoration by Mauro Pellicioli in 1948. This lent a homogeneous warm tone to the whole work, masking the presence of a large number of small retouches, all very precise but now discolored, and above all concealing the condition of the paint surface, which was highly compromised in places. The flesh tones of the two figures appeared most damaged: in many areas, the pink glazes were worn away almost completely, exposing the preparatory passages of *terra verde* (green earth pigment). The pictorial quality and volumetric handling of the few areas still in fine condition enable us to intuit what the expressive power of the two figures must have been. For example, the detail of the hand reveals how effectively Piero used reflected light to create that part of its contour in shadow by simply leaving the *terra verde* visible. Effects of this kind must have been present in other parts of the figures as well, but unfortunately, they have been lost due to abrasion. The shadow cast by the saint along the ground and onto the bench — highly naturalistic and inconsistent with other shadows, which are barely hinted at and are more symbolic in character — is very abraded, probably because it was erroneously interpreted as a layer of dirt. Fortunately, it was not removed entirely by a past intervention but was partially thinned out. The same can be said for the abrasion to the shoot emerging from the tree trunk at left, which was removed almost completely, probably because it was initially interpreted as discolored retouching. Other damages are the result of numerous and occasionally deep scratches in the lower part of the painting.

In the past, the picture surface has suffered from blistering along the edges of the craquelure, and these have been consolidated on a number of occasions — even after Pellicioli's restoration — and are still partly

Saint Jerome and a Supplicant before restoration under raking light

visible today. It was no doubt these consolidations, or more precisely the effects of rubbing with tools used to exert pressure on the areas of blistering, that caused much of the abrasion to the color along the ridges and the fracturing of the paint layer immediately adjacent to these raised areas. In other words, the damage was the result of the pressure employed to smooth out the blisters. The same sort of wear is found in the patina applied by Pellicioli, which appears irregular and concentrated in the cavities. Precisely because these glazes, varnishes, and the painting's condition itself were not homogeneous, the present cleaning was an extremely delicate task that was carried out painstakingly with the aid of a binocular microscope. The objective was to reduce the stained effect of the surface without further damaging its color.

To evaluate the work properly, we must bear in mind not only the instances of damage but also the changes caused by the natural aging of the material, particularly the alteration of pigments such as verdigris (especially in its copper resinate form) and red lake. The former was used extensively for vegetation and also for the saint's belt and has now acquired a characteristic transparent brown tonality quite distinct from its original brilliant green. The red lake passages also have lost much of their intensity, and this surely must have had a decisive impact on the description of volume in the supplicant's robe.

The removal of the retouching has revealed the presence, in the green of the background, of numerous open cracks, some of them quite deep. The deterioration of the ground may be the result of the use of a material that corroded it or simply weakened it and made it vulnerable. This damage surely happened long ago, since the losses are saturated with a good deal of wax and yellowed varnish. But the opening of the cracks could have been caused initially by a shifting of the color as the result of the incorrect or overabundant use of an oleo-resinous binder. There is no certain proof of this, and we would not be able to resolve any doubts, even with invasive techniques, since the original substances are deeply compromised by the numerous and varied instances of past efforts of consolidation to impede the blistering.

Cleaning has also enabled us to identify a change in the central part of the composition. What now appears as a dark patch in the area of the bench to the right of the saint, beneath the books, proved, after investigation, to be a passage of verdigris pigment later covered

by the bench. The size and character of the brushstrokes and the manner in which the paint was applied correspond perfectly with the areas of verdigris painted on the fields to the right to describe areas of shadow—evidence of an initially different compositional scheme that created a more direct spatial link to the valley in the center of the painting. This initial scheme was modified subsequently by extending the bench to the right of the figure with paint of a slightly different consistency from that used to paint the left-hand part. The modification therefore was done at a different time. The books on the bench were also added by Piero in a second moment, as can be deduced from the passage of verdigris beneath the surface paint that continues the contour of the slope at left. We thus have a significant compositional change that relates not only to the designing stage but also to a moment when Piero already had begun painting the background. Similar changes can be seen in features of the city, such as a bell tower at left; conversely, the position of the two figures was never modified, and this is confirmed by the fact that their contours often are defined by a slender area of reserve, where the white ground is visible.

Another interesting observation relates to the technique used for creating the oak tree. Piero originally painted the trunk and branches, and then—using verdigris, with the possible addition of black—he blocked out the darker areas of the foliage. Next, he painted the oak leaves one by one, first with red copper resinate (which is more transparent)—as with the leaves around the edges of the thickest foliage—and then gradually lightening the color and finally using pure yellow ocher for the brightly lit parts of the foliage. The same meticulous approach can be seen in other parts of the painting, such as the shrubs, olives, cypresses, and the lines partitioning the cultivated fields that enliven the landscape; the bushes of broom on the right; the chimneys and the crenellated walls of the city; the hairs of the fur lining of the supplicant's robe; the drops of blood on the crucifix; and the fictive lettering in the books. Also typical of Piero is the handling of the halo, which has a clearly defined thickness and which reflects the color of the saint's hair, although this detail is now barely perceptible.

Cleaning proceeded with a keen awareness of the condition of the picture surface, the natural alteration of certain colors, and the perfect state of conservation of other pigments (such as cinnabar, white lead, ultramarine blue). We then proceeded in stages, intervening on materials that had been applied in successive layers,

removing them with an eye to recovering a homogeneous luminosity and improved legibility of the picture's overall chromatic relationships. Pictorial integration, carried out almost exclusively in wash, aimed to reduce the disturbances caused in some areas by accentuated craquelure without fully eliminating the visual impact of the cracks. The same can be said about the abrasions to the picture surface, which have been only lightly concealed, chromatically uniting the residual glazes. The net result of this conservation, then, consists of "minimalist" integration, made possible by the quality of the painting itself, by the impact of its spaces and volumes, and by its great expressive power.

2. The Encounter, Nature, and Space: "Nel senso della forma la prospettiva . . ." (Roberto Longhi, L'arte, 1914)

by Roberto Bellucci and Cecilia Frosinini

The modest dimensions of this painting and the absence of an architectural setting should not deceive us. It is far from being a minor work—a one-off instance in Piero della Francesca's oeuvre, a mere step on the path to his artistic zenith. Nor can it be considered an incidental piece to which the artist committed himself reluctantly and without the extensive precision—that finely honed approach, compass and sextant in hand—that he employed in planning and designing his major works. Rather, in this little panel of Saint Jerome and a Supplicant, we have a grand demonstration of how Piero observed nature and landscape, unflinching in his certainty that the mathematical principles he so loved govern the world itself and not merely the representation of it. With great deliberation, after the almost hyperreal setting of the Baptism of Christ (see figure 3, page 11) and prior to the more summary one adopted for the Resurrection (see figure 19, page 35), the artist situated this sacred scene in a familiar landscape, that of the Upper Tiber Valley. Piero immersed his two figures—one sacred and atemporal, the other earthbound (Saint Jerome and Girolamo Amadi)—in a contrived setting composed of an iconographically determined proscenium (the saint's grotto and a desert-like plateau) that opens onto the world familiar to him.

As always happens with observations about works by Piero della Francesca, the technical aspects are as intriguing as the artistic ones. This factor may seem

Infrared reflectogram of Saint Jerome and a Supplicant

X-ray of Saint Jerome and a Supplicant

unexpected, and it is hardly fortuitous that it has come to the fore rather late in the evolution of Piero studies. But the point here is that the master's skill and his command of the medium were part and parcel of a tightly controlled vision, the aim of which was the realization of that vision rather than the exultation of the means by which it was achieved. This observation, however understated, might seem unusual to those artists who, one might say, are sidetracked by their professional interests and become enamored with the medium itself, placing it on almost the same plane as the aesthetic achievement.

One interesting discovery was the result of the chemical analysis of the preparation layer of the painting: the gesso binding proved to be made of parchment glue rather than the more usual animal-skin glue. Beyond the curiosity of this bit of information, the subject warrants our attention in a discussion of Piero's mature practice (a subject already discussed in the scholarly literature) and leads us to conjecture about what he was aiming for when he made this technical choice.[1] It seems noteworthy that there is a coincidence with the fact that in the 1470s, Piero established a *scriptorium* in Sansepolcro for the production of his treatises. As frequently happens, the technical fact, per se, can stand alone as no more than a curiosity: we would need similarly precise data from other works by the artist in order to establish a context—but the preparatory layer of a painting is often the last thing that interests anyone making an analysis of an object.

Notwithstanding the implications of past assertions,[2] infrared reflectography did not yield particularly special information about the underdrawing—the graphic character of Piero's work. Instead, we would draw attention to his use of incisions, which define the contours of both figures. The line is finely incised, so that it can elude notice from a certain distance, unless enhanced by magnification because of surface deterioration resulting from age. This sort of incision occurs in other works by Piero, for example in the contour of the figure of Federico da Montefeltro in the Brera altarpiece (see figure 4, page 12);[3] we also find it used extensively in the execution of the Senigallia Madonna and Child with Two Angels (cat. no. 4).[4] As in the case of the portrait of Duke Federico, here too the presence of an incised line in a work that was not intended to have a gold background may indicate the use by Piero of *patroni,* or as they might now better be called (from the findings of recent research), cartoons. On the basis

Detail of the crucifix in Saint Jerome and a Supplicant before restoration

of Piero's practice, we understand cartoons were used as a means of enlarging or reducing the scale of figures, thus enabling their repeated implementation throughout his career as templates, around which he incised the contour rather than transposing it by pouncing or tracing. Whether identified as *patroni* or cartoons, in general, Piero apparently used these reproductive techniques not to speed up the creative process, as was common workshop practice, but instead, to control the insertion of the figure in space and to obtain a sort of almost perfect creative identity of the kind modern terminology might call a trademark, that is, the repetition of stylistic elements and figure types that could be equated with their author. Such is the case here, where the figure of the donor, Girolamo Amadi, often has

been compared (partly in an effort to argue an identity different from the name written below him) with an older man in the Madonna of Mercy Altarpiece (see figs. 26 and 27, page 42), not to mention other figures in the Arezzo frescoes or the Flagellation (see figure 18, page 34). The resemblance shared by these figures is noteworthy so long as we also bear in mind Piero's use of mannikins,[5] a practice mentioned by Vasari, who wrote that "Piero made many models in clay, which he draped with damp cloth arranged with countless folds, to work from and use."[6] This technique for constructing figures can also be found in the illustrations of Piero's treatise De prospetiva pingendi, which were unequivocally based on mannikins. This practice was certainly not a novelty in painting, but it is particularly interesting to note the clear evidence of it in Piero's circle, possibly implying its adoption by his pupils. In this regard, it is worth drawing attention to a drawing by Luca Signorelli in the Robert Lehman Collection of the Metropolitan Museum (1975.1.420), in which we seem to witness the application of one of Piero's lessons from his treatise, the enlargement and reduction of figures, put into practice before our eyes.[7]

The evidence thus suggests that in the Saint Jerome and a Supplicant, the preparatory phase had a projectural function and related to the intellectual rather than simply the practical sphere. The use of mannikins and studies involving them as well as cartoons for re-scaling the figures gives us the measure of a creation that was controlled absolutely and strictly, in which nothing is left to improvisation or the painter's craft. Bearing this in mind (and it ought to be uppermost in studies of Piero della Francesca), we can now continue our examination of the whole painting in both its visible and invisible layers.

The extreme capacity for control that characterizes Piero's work is also expressed in his paintings with an outdoor setting, in which the rigor conferred by a painstakingly plotted architecture is diminished but in which we can nonetheless speak of an almost perspectival description of space. We see in this the determination of the three planes of the picture: the foreground, consisting of the rocky plateau on which the figures are posed, punctuated by a ridge running immediately behind the edge of the bench on which Saint Jerome is seated (this feature is clearly distinguishable with infrared reflectography); the second plane, provided by the cultivated valley, the city, and castle; and the third, consisting of the chain of hills that creates its own

spatial depth across three further partitions. This analysis can be continued by noting the inclusion of two separate yet simultaneous points of view, the one at the level of the beholder that defines the space where the figures meet and the bird's eye view of the valley. These contribute to the scene's distinct and spatially complex conception, in anticipation of the landscape in the Montefeltro portrait diptych (see figure 31, page 50).

It is particularly important to note how Piero achieved a spatial unity for the whole painting by pivoting its principal elements around a fulcrum that coincides with Amadi's eye. All those little indications that subtly allude to a privileged point of view converge at that point: the diagonals of the saint's bench, the arms of the cross, and those of the buildings in the city. This discovery contradicts what has been said, for example, by Roberto Longhi: it is not the city but man who is the focal point of the composition.[8] He is the measure of the world around him. Looking at the painting, it is this factor that seems in keeping with a fully evolved Humanism far more than the mere fact that there is no longer a hierarchy between the size of the donor and of the saint (indeed, if the two figures stood up, the donor would be the taller). The work's private destination certainly encouraged the subversion of this traditional hierarchy as well as the full expression of the new intellectual world, though the patron probably had as much to do with this as the artist did.

As is clear from infrared reflectography, the subsequent creative stage involved the application of a preparatory coat of paint consisting of a dark ground, evident in all the areas of landscape, in both the foreground and the background. The background was clearly painted around the figures, which were held in reserve. The paint is homogenous and is even coarsely applied in places, without the intention of following the outlines of the figure within the painted areas. It is interesting to note that Piero often used ground colors of this kind, even if this was more often the case with flesh tones, as happens with the Madonna of Mercy Altarpiece in the Pinacoteca, Sansepolcro, the Brera Altarpiece, or the Senigallia Madonna. His objective was evidently to condition the outcome of the final pictorial effect from a chromatic point of view. The strong registering of these passages with infrared could suggest that carbon black was among the materials used by Piero, even if non-invasive analysis (X-ray fluorescence) has offered no conclusive evidence, since the base element of carbon black was not found. Comparison

with analyses of other works by Piero offers a hypothetical parallel for the paint layers (including the final one) found in the pavement of the floor in the Brera Altarpiece. There, if one excludes the fictive marble effect, the floor is executed with a layer of black, which was then covered with white, rather than obtaining a gray by blending pigments.[9] Parallels could also be made with the colored grounds of the flesh tones in other works (as already has been suggested), in which the multilayer composition registers very dark with infrared reflectography, as in the ground color of our painting. In the Brera Altarpiece, the very dark flesh color of Saint John the Evangelist is seemingly due to the presence of copper resinate in the composition of the layers, to judge from examination with infrared. The flesh tones of the figures in our Saint Jerome with a Supplicant are instead lighter, even if they show little opacity under X-radiography, especially in the figure of Amadi. In similar cases, such as the Senigallia Madonna, the analytical report notes the presence of a white color, "to be defined," with little radio-opacity.[10] This could be a lime white pigment (*bianco di San Giovanni*), the presence of which in panel paintings has been variously noted in recent studies. In any case, the fact remains that Piero intentionally sought a livid effect, especially in the flesh tones, probably to offset the white preparation.

Regarding the interpretation of scientific analysis, it should be emphasized that the very complexity of the treatment of ground colors often has led to confusion and the discussion of pentimenti or adjustments to the contours of the figures. In fact, the painting does not show pentimenti, or revisions made during the pictorial phase. It is the broad brushstrokes of the basic background passages, used to surround the figures, and the extensive method of holding areas in reserve that foster the erroneous perception that the difference in materials is a sign of adjustments made during the execution of the work. During the pictorial phase, through a minimal but effective treatment of shadows created with *terra verde*, Piero built up the anatomy of Saint Jerome and that of the few exposed parts of Girolamo Amadi, such as veins, tendons, and ribs, which then were highlighted with light touches of white lead. It does not seem that this modeling is part of the preparatory phase but belongs to the actual painting stage, since infrared reflectography has not revealed any trace of the wash brushstrokes that are typical of so-called undermodeling.[11]

To conclude the discussion of purely technical data, we would like to address the question of the medium used by Piero in this painting. From what we have observed, the work was executed with a mixture of tempera (in the flat foreground, for example) and oil (apart from its necessary use for verdigris, it appears that oil was also used for the city, the figures' clothing, the sky, etc.). It is important, however, to underline that the recent tendency to use this alternation between tempera and oil as evidence for dating is too deterministic. Once he learned to use oil correctly, Piero made his choices based on the effects he wanted to achieve. He did not abandon one technique for the other. For example, the presumed use of tempera in the flesh tones of the figures in the portraits in the Uffizi (see figure 31, page 50), as compared with the use of oil for the corresponding passages in the Brera Altarpiece,[12] might lead one to think that the Uffizi panels preceded the altarpiece in Milan, rather than suggesting a voluntary choice in favor of the more traditional technique to produce a dynastic and celebratory portrait. The idealization of the sovereign, probably requested by the patron himself, may have been sought by the painter, who not only turned to the traditional, medal-like iconography of profile portraiture but also to a technique more in keeping with the archaizing elements of the picture. The fact that the background of the Uffizi double portrait, too, was painted by Piero with a different, more "modern" technique, and above all more appropriate to the atmospheric depiction of a distant landscape, might suggest that he made a conscious choice and thus made a deliberate distinction between the character of the tasks. Clearly, this interpretation, based on the current state of scholarship, dismisses the possibility of using technical analysis for the purposes of dating these paintings.

Finally, it is interesting to start offering an assessment—if only a preliminary one—of the work's enhanced legibility thanks to its cleaning. There are numerous elements that now enable us to have a better sense of Piero della Francesca's intentions and achievements. The setting of the composition is much clearer now, with a newly recovered sense of the diminution of background landscape, with its triple edge of hills, but also (and above all) an improved understanding of how the foreground elements are arranged. For example, we can now see that the truncated tree at left—supporting the cross that inventively reminds us of the tree growing over the grave of Adam—stands in the immediate foreground with a clear space between it and the figure of Saint Jerome and also between it and the cavern hollowed out of the hillside. The volumetric rendering of

this tree situates the saint farther back, thus lending the summary depiction of the story of Salvation (from Adam to Christ) a spatial prominence, a fact that then as now surely invited the beholder to read it as the interpretive key to the work.

Worthy of mention, among the passages obscured until now by yellowish surface patinas, are a number of elements: the double enclosure of city walls, its outer ring adjoining the cultivated fields of the little valley; the copious, seemingly endless chimney tops, created with small touches of gray, on the city's roofs; the halo of the crucified Christ, a solid disk with its own clearly identifiable thickness, for all its minimal dimensions; and the extraordinary concept, more luministic than perspectival, of Saint Jerome's halo, which is not only reflective, mirroring the cranium of the saint's head, but also transparent, set against the cultivated slopes of the hills. The idea it suggests is that of a disk of yellow glass.[13]

Cleaning also has made it possible to read some physical details of the vegetation in the foreground: the bark of the oak tree, the creeper (perhaps ivy) climbing up the tree trunk below the cross, and the botanically recognizable oak leaves. As already noted, Piero devoted himself with painstaking, almost obsessive attention to defining foliage, first constructing the skeleton of the tree, its trunk, and its branches, and then painting individual leaves one by one, to obtain the mass of foliage itself. The foliage was certainly more vibrant before it became discolored, given his use of three different tonalities, gradually modulated, of verdigris, sometimes alternating with yellow (and still visible) leaves.

The transparent verdigris that defines all the vegetation on the hills and in the valley (applied as such and not as a glaze over a darker green) originally must have been much lighter and more brilliant, giving the landscape unequivocal signs of spring, further reinforced by the flowering broom. In this context, it is worth noting how Piero makes use here of a concise symbolism in his choice of single items of vegetation, iconologically defining his figures by associating their character with a relative botanical element. The two bushes of broom at right would reflect an aspect of the patron, symbolizing tenacity and flexibility—a man who knows how to survive and flourish when facing adversity but who is at the same time modest and humble before his name-saint. On the other hand, the ivy growing on the tree trunk at left is one of the symbols of Saint Jerome[14] because of a well-known dispute with Saint Augustine regarding the translation, in the Book of Jonah of the Old Testament, of the Hebrew term *kikayon* by the Latin *hedera* (in Italian, *edera*: ivy) instead of the more common *cucurbita* (gourd). The debate was commented on much by Humanists as an example of Jerome's erudition and critical rigor. Thus, the appearance of ivy, together with the saint's gesture, handling several pages at a time (underlined by various scholars), would seem to emphasize his intellect more than his penitence.

The consideration of these iconological features, facilitated by the cleaning of the painting, raises a question: if Piero needed to enter into all these details in order to convey meaning, was the landscape setting—with its hills and especially the turreted city and castle, each depicted with a very careful descriptive purpose—also intended to be identifiable? The absence of a precise reason for identifying the city as Sansepolcro and its surrounding landscape, especially now that we have a greater certainty about the patron, leads us to explore other possibilities. Indeed, why represent Sansepolcro in a work in which that particular city is unrelated to the patron, Girolamo Amadi? The explanation that Piero always represents his own city does not make sense here, in a work so intimately connected with its patron and not intended for public viewing. Ruling out, for obvious reasons, the depiction of Amadi's native city of Venice, there remains the possibility that we are looking at a depiction of Lucca, the city of the Amadi family's origins, with which they continued to have links and which provided both Girolamo and his brother with their wives. The identification of the city in the painting with the tower-studded Lucca of Piero's day, depicted on a number of occasions in devotional paintings of the fourteenth and fifteenth centuries[15]—and cited by Fazio degli Uberti in his *Dittamondo*, with the celebrated verse: "Moving on, we saw Lucca in a little circle, towering like a copse of trees" (*Andando noi vedemmo in piccol cerchio, torreggiar Lucca in guisa di boschetto*)—might be a suggestion for resolving this question.

Note: Conservation treatment on Piero della Francesca's Saint Jerome and a Supplicant was carried out by the Opificio delle Pietre Dure, Florence, between February and September 2013. Soprintendente: Marco Ciatti, Directors: Marco Ciatti and Cecilia Frosinini, Conservation: Chiara Rossi Scarzanella, Diagnostic project: Roberto Bellucci, High-resolution photography: Roberto Bellucci, Infrared reflectography with multi-NIR scanner (INO-CNR): Roberto Bellucci, X-radiography: Ottavio Ciappi, X-fluorescence and paint layer analysis: OPD Scientific Laboratory, coordinated by Carlo Galliano Lalli, Directed by Giancarlo Lanterna

PIERO DELLA FRANCESCA
PERSONAL ENCOUNTERS

BY KEITH CHRISTIANSEN

1. Aldous Huxley, "The Best Picture," in *Along the Road: Notes and Essays of a Tourist* (London, 1925), pp. 184–96 (quotation on p. 185). Like so many viewers, Huxley was fascinated by the lack of dramatic emphasis in Piero's work—what Bernard Berenson, in a monograph on the artist of 1950, termed the art of the ineloquent—and the absence of "any particular sympathy with the religious or emotional significance" (p. 189). Not the least fascinating aspect of Huxley's essay is his description of just how difficult it still was to get to Sansepolcro and how very long and arduous the journey was from Urbino. Even in a motor bus, the trip took "something over seven hours. No joke, that journey, as I know by experience" (p. 184).

2. Because of the high-flown critical language that so frequently describes Piero's art, it is worth noting Ernst Gombrich's brilliant review of Kenneth Clark's classic monograph of 1952; see *Burlington Magazine* 94 (June 1952), pp. 176–78. Gombrich remarks: "It is a curious paradox that the art of Piero, the art which Bernard Berenson recently represented as the prototype of *l'arte non eloquente* should thus have given rise to a revival of eloquence in criticism. For Sir Kenneth Clark is not the first author so to respond to the challenge of Piero's remote and reticent beauty. Möller van der Bruck and R. Longhi, J. v. Schlosser and Adrian Stokes, each according to his lights and to his command of language, have all felt the need to translate their experience of Piero's 'impersonal' art into a very personal imagery." In his monograph of 1952, Clark had updated Longhi's post-impressionist frame of reference by comparing the face of the Madonna della Misericordia to African masks, yet another indication of the way Piero's art has been embraced by modernist aesthetic values.

3. This quasi-fetishistic fascination with Piero's work—to which art historical scholarship has not been immune—was beautifully captured in Sir John Mortimer's 1988 mystery, *Summer's Lease*, which the following year became a wildly popular BBC series. John Pope-Hennessy, *The Piero della Francesca Trail* (London, 1991), parodied this phenomenon and used the series as the point of departure for his thoughts on the artist.

4. There are, nonetheless, three paintings of the Madonna and Child that can be closely associated with Piero; they are in Christ Church, Oxford, the Boston Museum of Fine Arts, and the Collezione Cini in Venice. Two of these may be works by the young Signorelli, who apprenticed with Piero; see the entries by Raffaele Caracciolo in *Luca Signorelli*, ed. Fabio De Chirico et al., exh. cat., Galleria Nazionale dell'Umbria, Perugia, Museo dell'Opera del Duomo, Orvieto, and Pinacoteca Comunale, Città di Castello (Cinisello Balsamo, 2012), pp. 297–99, nos. 3–5; and Alessandro Angelini, "Per la cronologia del dittico dei Montefeltro di Piero della Francesca," *Prospettiva*, nos. 141–42 (January–April 2011), pp. 70–71.

5. Roberto Longhi, *Piero della Francesca*, new ed. (Florence: Sansoni, 1975), p. 285. The first edition of Longhi's book appeared in 1927; the second in 1942; and the third in 1963.

6. Our information on Piero's family and his early career in Sansepolcro has been transformed through the archival discoveries of Frank Dabell, "Antonio d'Anghiari e gli inizi di Piero della Francesca," *Paragone* 35, no. 417 (November 1984), pp. 73–94; and James R. Banker, "Piero della Francesca as Assistant to Antonio d'Anghiari in the 1430s: Some Unpublished Documents," *Burlington Magazine* 135 (January 1993), pp. 16–21. I would like to thank both for sharing their thoughts and, in the case of James Banker, for allowing me to read parts of his forthcoming book. The documents are reviewed in a variety of journals and exhibition catalogues, for which see the bibliography in Nathaniel Silver et al., *Piero della Francesca in America: From Sansepolcro to the East Coast*, exh. cat., Frick Collection (New York, 2013). A good survey of what we know of Piero's family can be found in James R. Banker, "Piero della Francesca: Gli anni giovanili e l'inizio della sua carriera," in *Città e corte nell'Italia di Piero della Francesca: Atti del Convegno Internazionale di Studi, Urbino, 4–7 ottobre 1992*, ed. Claudia Cieri Via (Venice, 1996), pp. 85–95; and James R. Banker, *The Culture of San Sepolcro during the Youth of Piero della Francesca* (Ann Arbor, 2003), chap. 4, "The Family of Benedetto and Romana della Francesca," pp. 127–58.

7. See Frank Dabell, "Piero della Francesca e i pittori prospettici," in *Arte in terra d'Arezzo: Il Quattrocento*, ed. Liletta Fornasari, Giancarlo Gentilini, and Alessandra Giannotti (Florence, 2008), p. 116.

8. See Banker, *Culture of San Sepolcro* (see note 6 above), pp. 151–52. For the importance of woad (*guado*), see Franco Polcri, "Produzione e commercio del guado nella Valtiberina Toscana nel '500 e nel '600," *Proposte e ricerche* 28 (1992), pp. 26–38; and Franco Polcri, "Sansepolcro: La città in cui Piero della Francesca prepara il suo rapporto con le corti," in *Città e corte nell'Italia di Piero della Francesca*, ed. Cieri Via (see note 6 above), p. 100.

9. See James R. Banker, "The Second 'Casa di Piero della Francesca': Hypotheses on Piero's Studio and His Role as Builder in Borgo San Sepolcro," in *Mosaics of Friendship: Studies in Art and History for Eve Borsook*, ed. Ornella Francisci Osti (Florence, 1999), pp. 148–50.

10. See Paul F. Grendler, "What Piero Learned in School: Fifteenth-Century Vernacular Education," in *Piero della Francesca and His Legacy*, ed. Marilyn Aronberg Lavin, Studies in the History of Art 48, Center for Advanced Study in the Visual Arts, Symposium Papers 28 (Washington, D.C., 1995), pp. 161–74; and J. V. Field, *Piero della Francesca: A Mathematician's Art* (New Haven, 2005), pp. 73–76. Banker, *Culture of San Sepolcro* (see note 6 above), pp. 57–92, has examined the availability and unavailability in Sansepolcro of these schools.

11. See Margaret Daly Davis, *Piero della Francesca's Mathematical Treatises: The "Trattato d'abaco" and "Libellus de quinque corporibus regularibus"* (Ravenna, 1977); and Field, *Piero della Francesca* (see note 10 above), who attempts to analyze Piero's art in terms of his mathematic interests. In the 1470s, Piero created a scriptorium for the production of manuscripts, and this must have greatly limited the time he could devote to painting.

12. We first hear of Piero's modest activities as an independent artist in 1431, when he was paid for painting candles for a religious confraternity of laymen who gathered for the singing of hymns (the Laudesi di Santa Maria della Notte). The following year, he assisted Antonio d'Anghiari by preparing the panels for an ambitious double-sided altarpiece for the church of San Francesco. As fate would have it, in 1437, the unfulfilled commission was transferred to the great Sienese painter Sassetta, who ordered new panels for the occasion; in 1451 the still unpainted panels prepared by Piero were sold by the Franciscans to the Augustinians, who in 1454 commissioned their now celebrated native son—Piero—to paint them in an entirely more progressive style. It is indicative of the conservative taste in Sansepolcro that Piero was repeatedly commissioned to fulfill lapsed commissions and to work on old-fashioned Gothic polyptychs designed by his predecessors. Between 1433 and 1438, he collaborated with Antonio on a variety of projects, ranging from the preparation of banners for display on the four principal gates of the city to the decoration of a chapel, an altarpiece for the nearby town of Citerna, and the image of the Annunciation in the church of Sant'Agostino in Sansepolcro.

13. No certain paintings by Antonio d'Anghiari are known; see Andrea De Marchi, "Antonio da Anghiari e gli inizi di Piero," in *Arte in terra d'Arezzo*, ed. Fornasari, Gentilini, and Giannotti (see note 7 above), pp. 99–106.

14. Perhaps the most compelling reconstruction of the impact of Florence on Piero is that of Luciano Bellosi, "Sulla formazione fiorentina di Piero della Francesca," in *Una scuola per Piero: Luce, colore, e prospettiva nella formazione fiorentina di Piero della Francesca*, ed. Luciano Bellosi, exh. cat., Galleria degli Uffizi, Florence (Venice, 1992), pp. 17–53. For a fine summary, see Antonio Paolucci, "Da Borgo Sansepolcro a Firenze: La formazione," in *Piero della Francesca e le corti italiane*, ed. Carlo Bertelli and Antonio Paolucci, exh. cat., Museo Statale d'Arte Medievale e Moderna, Arezzo (Milan, 2007), pp. 21–27.

15. From the dedication to Brunelleschi of the Italian edition of Alberti's treatise on painting, the *De pictura*, written in 1435 (Leon Battista Alberti, *On Painting and On Sculpture: The Latin Texts of De pictura and De statua*, ed. Cecil Grayson [London, 1972], pp. 32–33).

16. For the current view of these panels, long thought to have been painted for the Medici palace, see the masterly summary of Dillian Gordon, *The Fifteenth Century: Italian Paintings*, vol. 1, National Gallery Catalogues (London, 2003), pp. 387–93. They probably date to the late 1430s.

17. The inscription reads: *Di M[esser] Lionardo da Vinco / Ritoccata da Sandro Rosi l[ann]o 1686.* Curiously, the date was misread by Longhi as 1655. There really is no question that it is 1685; see Frank Dabell, "Piero della Francesca: Arezzo, Monterchi and Sansepolcro," *Burlington Magazine* 149 (August 2007), p. 581, n. 7. For the most thorough and convincing analysis of the picture, see De Marchi, "Antonio da Anghiari" (see note 13 above), p. 106; and, more extensively, Andrea De Marchi, *The Alana Collection*, vol. 2, *Italian Paintings and Sculptures from the Fourteenth to the Sixteenth Centuries*, ed. Miklós Boskovits (Florence, 2011), pp. 224–30. In 1682, Rosi was paid for restoring Ridolfo del Ghirlandaio's altarpiece of the ten thousand martyrs, described as "tutta guasta, e scolorita"; see Elisa Acanfora, *Alessandro Rosi* (Florence, 1994), p. 191, where the ex-Contini picture is also mentioned under the correct date of 1685, as properly read by Silvia Meloni Trkulja.

18. The cleaning was undertaken by David Bull, who did not attempt to disguise the generally worn appearance of the Madonna and Child. Most losses are small and have been discretely inpainted; a major loss is in the veil of the Virgin above her proper left forehead. The reverse side has not suffered from the solvent damage that so affects the Virgin and Child, and aside from the self-evident losses, it is in good condition. The picture has been examined at the Metropolitan by Dorothy Mahon of the conservation department. She reports that there is evidence throughout of a faded red lake pigment, the original, intensely cherry red color of which can be seen along the edges of the cracks in the architectural surround, where it has been preserved by the upper layers. This, in addition to the generally very abraded condition, surely contributes to the bleached appearance the picture now has. The flesh must have been colored entirely with red lake, although here, there are only occasional areas of preserved red lake because the original tincture was so delicate. There is also red lake visible throughout the Madonna's robe, mixed in with the mineral blue pigment. This is most abundant in the shadows. Perhaps the red lake was just used to deepen the shadows, but the robe originally may have been more purplish overall. That would have worked very well with the red lake. The original coloration of the painting must have been stunning.

19. A technical examination and X-ray made at the Metropolitan Museum has revealed that the panel is from the front of a cassone. The cavity is where the lock mechanism was inserted; the keyhole is still visible on the side with the Madonna and Child. Does this suggest that the scene of the wine cooler, which is centered on the keyhole, was one of three and that the original intention was to create a feigned intarsia front? Or was the wood simply salvaged from a disassembled cassone and then re-used first for a perspective demonstration and then for a painting of the Madonna and Child?

20. For an analysis of the perspective drawings usually ascribed to Uccello, see the entries by Martin Kemp in *Circa 1492: Art in the Age of Exploration*, ed. Jay A. Levenson, exh. cat., National Gallery of Art, Washington, D.C. (Washington, D.C., and New Haven, 1991), pp. 241–43, nos. 139–41. For an analysis of the relation of perspective to the development of the cartoon, see Carmen Bambach Cappel, "Piero della Francesca, the Study of Perspective and the Development of the Cartoon in the Quattrocento," in *Piero della Francesca tra arte e scienza: Atti del Convegno Internazionale di Studi, Arezzo, 8–11 ottobre 1992, Sansepolcro, 12 ottobre 1992*, ed. Marisa Dalai Emiliani

and Valter Curzi (Venice, 1996), pp. 143–66; and Carmen Bambach, *Drawing and Painting in the Italian Renaissance Workshop: Theory and Practice, 1300–1600* (Cambridge, 1999), pp. 222–33. Interestingly, Ronald Lightbown, *Piero della Francesca* (London, 1992), p. 25, misinterpreted the reverse of the ex-Contini painting as a perspective drawing pasted down onto the panel.

21. The correlation was noted by Giovanni Romano, *Il coro di San Lorenzo*, Monumenta Albensia 1 (Alba, 1969), p. 13, and is commented on by De Marchi, *Alana Collection*, ed. Boskovits (see note 17 above), p. 230, n. 19. So far from being a mere perspectival rendering of an object, in this case, Piero had in mind an anamorphic projection—a tour-de-force demonstration—which gives an idea of the degree to which the science of perspective fascinated him no less than it did Uccello. Vasari in fact records "un vaso in modo tirato a quadri e facce che si vede dinanzi, di dietro e dagli lati, il fondo e la bocca: il che è certo cosa stupenda" ("A vessel drawn with squares and facets so that it was shown from the front and back and sides, the bottom and top: which was certainly a stupendous thing"); Giorgio Vasari, *Le vite de' più eccellenti pittori, scultori e architettori: Nelle redazioni del 1550 e 1568*, ed. Rosanna Bettarini and Paola Barocchi, vol. 3 (Florence, 1971), pp. 258–59. For the relevant passage in the *De prospetiva pingendi*, with the detailed instructions, see book 3, par. 11.

22. For example, by De Marchi, *Alana Collection*, ed. Boskovits (see note 17 above), p. 229.

23. See Romano, *Il coro di San Lorenzo* (see note 21 above), pp. 13–15, for a discussion of the importance of practice of intarsia for Piero. For the documents and history of the intarsia decoration of the sacristy as well as questions of attribution, see Margaret Haines, *The "Sacrestia delle Messe" of the Florence Cathedral* (Florence, 1983), pp. 61–73, 99–109.

24. See Pier Luigi Bagatin, *L'arte dei Canozi lendinaresi* (Trieste, 1990), pp. 32–38. For an overview of the Lendinaras' work at Ferrara, see Marcello Toffanello, *Le arti a Ferrara nel Quattrocento: Gli artisti e la corte* (Ferrara, 2010), pp. 104–9.

25. For example, by Carlo Bertelli, "Piero da Perugia a Roma," in *Piero della Francesca e le corti italiane*, ed. Bertelli and Paolucci (see note 14 above), p. 31, and pp. 200–201, no. 5; and De Marchi, *Alana Collection*, ed. Boskovits (see note 17 above), pp. 224–30.

26. The artist, formerly known only as the Master of Pratovecchio, after the town for which he painted a major altarpiece, now has been identified as Francesco di Giovanni, who worked with Filippo Lippi between 1440 and 1442. For a review of the documents, see Takuma Ito, "L'identità di Giovanni di Francesco," in *Intellettuali ed eruditi tra Roma e Firenze alla fine del Settecento*, Ricerche di storia dell'arte 84 (Rome, 2005), pp. 51–69.

27. Scheggia's painting, showing the Madonna and Child in a box-like interior with the ceiling foreshortened to be seen from below, dates from the 1430s but clearly derives from Donatello's sculptural relief in Berlin, the Pazzi Madonna, usually dated to about 1419; see Luciano Bellosi and Margaret Haines, *Lo Scheggia* (Florence, 1999), pp. 19–20, 81; and Laura Cavazzini, *Il fratello di Masaccio: Giovanni di Ser Giovanni detto lo Scheggia*, exh. cat., Casa Masaccio, San

Giovanni Valdarno (Florence, 1999). Together with Gentile da Fabriano's Madonna and Child in the Yale University Art Gallery, Donatello's marble relief is a reminder that the window or parapet motif was not exclusive to the 1430s. But it is in the 1430s and 1440s that it was taken up by a variety of artists and explored in remarkably innovative ways. We need only think of Giovanni Boccati's Madonna and Child in the Berenson collection at I Tatti to realize the impact of the experiments in Florence on itinerant artists passing through the city.

28. Kenneth Clark, *Piero della Francesca* (London, 1951), p. 12, in speaking of the handling of space in the Baptism of Christ.

29. Mario Salmi, "Un'ipotesi su Piero della Francesca," *Arti figurative* 3, nos. 2–4 (April–December 1947), pp. 78–84, accepted Longhi's attribution, following which it was marginalized to the category of "attributed to Piero"—an understandable stance, considering its inaccessibility and the dearth of documents relating to Piero's training and early years in Sansepolcro. Eugenio Battisti, *Piero della Francesca* (1971; rev. ed., Milan, 1992), p. 562, no. d.9, considered it only a school piece, as did Antonio Paolucci, *Piero della Francesca* (Florence, 1989), p. 251, ill. nos. 23, 24. Typical of the prevailing attitude toward it is the comment of Field, *Piero della Francesca* (see note 10 above), p. 76, who simply noted it as a work "whose ascription to Piero has been doubted." Yet, it has been accepted—again, on the basis of the photographs published by Longhi and largely on the strength of his reputation, by a number of scholars, including Stefano Bottari, Giovanni Romano, Massimo Ferretti, Michel Laclotte, Alessandro Angelini, Luciano Bellosi, Andrea De Marchi, and Ronald Lightbown (*Piero della Francesca* [see note 20 above], p. 25). For a comprehensive bibliography, see De Marchi, *Alana Collection*, ed. Boskovits (see note 17 above). The conservation work provides a new point of departure.

30. Umberto Baldini in *Mostra di quattro maestri del primo Rinascimento*, exh. cat., Palazzo Strozzi (Florence, 1954), p. 120, no. 50, as "attribuito a Piero della Francesca."

31. *Piero della Francesca e le corti italiane*, ed. Bertelli and Paolucci (see note 14 above), pp. 200–201, no. 5, with an entry by Carlo Bertelli arguing strongly for its reconsideration (in his monograph of 1992, he had omitted any discussion of the picture). It is discussed by Frank Dabell in his review of the exhibition, where he points out the analogy of the pose of the Virgin with a Madonna and Child by Spinello Aretino in Città di Castello; see Dabell, "Piero della Francesca: Arezzo, Monterchi and Sansepolcro" (see note 17 above), pp. 580, 581, n. 6. As remarked above in note 17, the fullest discussion is in De Marchi, *Alana Collection*, ed. Boskovits, pp. 224–30.

32. See Dabell, "Piero della Francesca: Arezzo, Monterchi and Sansepolcro" (see note 17 above), p. 580; and De Marchi, *Alana Collection*, ed. Boskovits (see note 17 above), p. 228.

33. Adriano Franceschini, *Artisti a Ferrara in età umanistica e rinascimentale: Testimonianze archivistiche*, pt. 2, vol. 1 (Ferrara, 1995), p. 608, app. 9. The possible implications of the document are discussed by Matteo Mazzalupi, "'Uno se parte dal Borgo . . . e va ad Ancona': Piero della Francesca nel 1450," *Nuovi studi*, no. 12 (2006), p. 37.

34. See Banker, "Second 'Casa di Piero della Francesca'" (see note 9 above), pp. 148–62.

35. For a review of what the early sources have to say about the places where Piero works, see Frank Dabell, "'Comme apare in Urbino, Bologna, Ferrara, Arimino, Ancona': Piero della Francesca, fonti e testimonianze," in *Melozzo da Forlì: L'umana bellezza tra Piero della Francesca e Raffaello*, ed. Daniele Benati, Mauro Natale, and Antonio Paolucci, exh. cat., Musei San Domenico, Forlì (Cinisello Balsamo, 2011), pp. 31–35.

36. The picture was purchased by the Berlin museums from a private collection after three years of negotiations; see Wilhelm von Bode, "Der hl. Hieronymus in hügliger Landschaft von Piero della Francesca: Neuerwerbung des Kaiser-Friedrich-Museums," *Jahrbuch der preussischen Kunstsammlungen* 45 (1924), pp. 201–5. The much repainted state of the picture is evident in the published illustration.

37. On the popularity of Saint Jerome in the Renaissance, see Eugene F. Rice Jr., *Saint Jerome in the Renaissance* (Baltimore, 1985), especially chap. 4, "Divus litterarum princeps," pp. 84–115. Rice notes that images of Jerome in the wilderness with his books and writing implements far outnumbered depictions of him in his study.

38. Michael Baxandall, *Giotto and the Orators: Humanist Observers of Painting in Italy and the Discovery of Pictorial Composition, 1350–1450* (Oxford, 1971), p. 92; and *Verona illustrata*, no. 8 (1995), pp. 36–42 (special issue, *Documenti e fonti su Pisanello*, ed. Dominique Cordellier). Baxandall has commented on the fact that the observations amount to a rehearsal of well-known Classical texts.

39. The lunette is in the Galleria Sabauda in Turin. For a reconstruction of the altarpiece and the history of the chapel, see Mazzalupi, "'Uno se parte dal Borgo . . .'" (see note 33 above), pp. 44–46.

40. For the connection of the picture with the Ferretti, see ibid.

41. For the results of the cleaning and a reconsideration of the picture, see Robert Oertel, "'Petri de Burgo opus,'" in *Studies in Late Medieval and Renaissance Painting in Honor of Millard Meiss*, ed. Irving Lavin and John Plummer (New York, 1977), vol. 1, pp. 341–51. According to the museum notes made by Dr. Hermann Kühn, who examined and cleaned the picture, the medium is oil—such as linseed or walnut oil. Analysis of the pigments used in the repainting suggested a date prior to the eighteenth century. My thanks to Stefan Weppelmann for making these notes available to me.

42. For Piero's interest in optics, see especially John Shearman, "Refraction, and Reflection," in *Piero della Francesca and His Legacy*, ed. M. A. Lavin (see note 10 above), pp. 213–21.

43. The forest as a metaphor for ignorance and sinfulness is almost ubiquitous. We find it not simply in the opening lines of Dante's great journey in the *Inferno*, but, for example, in Saint Augustine's address to God in *The Confessions* (10.35): "In this immense forest, so full of snares and dangers, I have pared away many sins and thrust them from my heart, for you have given me the grace to do this, O God, my Saviour."

44. The paint surface retains its original raised edge, or *barbe*, on the vertical edges but has been reduced top and bottom. The extended bare panel at the sides has been trimmed by as much as 3 centimeters, but there are indications of nails where an engaged frame once was applied. A detailed technical report was made for the exhibition of the picture in 2007; see Giulio Manieri Elia in *Piero della Francesca e le corti italiane*, ed. Bertelli and Paolucci (see note 14 above), pp. 196–99. For a technical report based on the most recent cleaning and technical exam, see the essay on pp. 73–81 in this catalogue.

45. See Battisti, *Piero della Francesca* (see note 29 above), p. 518; and Manieri Elia in *Piero della Francesca e le corti italiane*, ed. Bertelli and Paolucci (see note 14 above), p. 196.

46. Longhi, *Piero della Francesca* (1975 ed.; see note 5 above), pp. 38, 259, dated it somewhere between 1440 and 1450 in the 1927 edition of his monograph and "towards 1450" in the notes to the 1942 edition, where he also suggested that it was painted in Venice following Piero's work in Ferrara. By contrast, Creighton Gilbert, *Change in Piero della Francesca* (New York, 1968), pp. 114–15, put into play the idea that it should be dated to about 1475, when, he noted, the brother of Girolamo Amadi, Francesco, was an ambassador to several cities in Tuscany. He saw stylistic connections with the Montefeltro portrait diptych in the Uffizi. Virtually all subsequent literature has opted for one or the other of these two dates, regardless of their acceptance of the identification of the donor, with a preponderance favoring a date around 1450—close, that is, to the Berlin picture. For a review of opinions, see Battisti, *Piero della Francesca* (see note 29 above), pp. 518–22, who sustains a late dating; and Sergio Marinelli, "Piero della Francesca e la pittura veneta," in *Piero Francesca tra arte e scienza*, ed. Dalai Emiliani and Curzi (see note 20 above), pp. 444–48.

47. For a cogent summary of the "Piero and Venice question," first articulated by Roberto Longhi in his monograph on Piero, see Mauro Lucco, "'La primavera del Mondo tuto, in ato de Pitura,'" in *Giovanni Bellini*, ed. Mauro Lucco and Giovanni Carlo Federico Villa, exh. cat., Scuderie del Quirinale, Rome (Milan, 2008), pp. 28–30. Lucco is skeptical of Piero's influence on Bellini, usually adduced for the new perspectival vision in Bellini's altarpiece of the Coronation of the Virgin for the church of San Francesco, Pesaro. Certainly, if he made a trip to Pesaro to sign a contract for the altarpiece, he would have to be able to study Piero's work in Ancona and Rimini. Oertel, "'Petri de Burgo opus'" (see note 41 above), p. 349, makes the contrary case: that Piero's landscape is indebted to the example of Jacopo Bellini, whose work Piero would have known in Ferrara.

48. For a survey of the various dates assigned to it, ranging from about 1444 to about 1460–70, see Carlo Bertelli, *Piero della Francesca* (Venice, 1992), p. 184. James R. Banker, "Piero e i suoi libri a Sansepolcro," in *Piero della Francesca e le corti italiane*, ed. Bertelli and Paolucci (see note 14 above), p. 10, and Emanuela Daffra, "Urbino e Piero della Francesca," in *Piero della Francesca e le corti italiane*, ed. Bertelli and Paolucci, pp. 56–57, both make strong cases for dating it to the late 1450s.

49. Most recently Alessandro Marchi has discussed the primacy of architecture in depictions of the Flagellation; see *La città ideale: L'utopia del Rinascimento a Urbino tra Piero della Francesca e Raffaello*, ed. Alessandro Marchi and Maria Rosaria Valazzi, exh. cat., Galleria Nazionale delle Marche, Palazzo Ducale, Urbino (Milan, 2012), pp. 213–14. It is worth pointing out that Piero consciously pairs or contrasts an urban and a landscape setting in his fresco of the discovery and proving of the cross in his fresco cycle at Arezzo. Because of the

interest in perspective and mathematics, Piero's landscape settings have attracted less attention than his urban views. Yet they engaged him as fully and posed problems just as complex from the point of view of optics and the depiction of space.

50. Longhi, *Piero della Francesca* (1975 ed.; see note 5 above), p. 38, "Qui uomini e santi, di eguale caratura nella cerchia del paese, si accostano ed accomodano ad una familiarità rustica il cui senso è tutto immerso nello spettacolo dell'ora alta e combusta. Non più centralità dommatica nel vago specchio del quadro, ché anzi il centro matematico di esso viene ad essere occupato dall'apparizione lontana della città intonacata dagli uomini; e, per tutti i lati, dal tronco tagliato sul primo piano a quell'albero dietro il devoto, alle vibrate zone dei monti e del cielo, è un libero immettersi nello spazio di persone e di cose. L'uomo perde così la sua facoltà di servir di metro al mondo, com'era in quei giorni il pensiero dei fiorentini, terribili antropomorfisti, e perde financo i suoi consueti riferimenti. . . ."

51. Piero was not alone in showing Jerome studying rather than performing an act of penitence. Dillian Gordon, *Fifteenth Century: Italian Paintings* (see note 16 above), pp. 52–54, outlines the principal treatments at the court of Ferrara.

52. For a survey of the documentary evidence relating to Girolamo Amadi, see the contribution of Anna Pizzati in this catalogue. Two further contributions worth noting are those of Marinelli, "Piero della Francesca e la pittura veneta" (see note 46 above), pp. 444–48; and Andrea Calore, "Piero della Francesca e Girolamo Amadi: Chiarificazioni e aggiunte," *Bollettino del Museo Civico di Padova* 89 (2000), pp. 17–28.

53. It is worth recalling that Piero had ample occasion to see Etruscan vases: Vasari recounts how Piero's Aretine colleague Lazzaro Vasari (1399–1468) — Vasari's great-grandfather — had a son, Giorgio, who was much devoted to Etruscan vases and indeed, revived their technique (Lazzaro's father had been a potter). Giorgio made a gift of some of the vases he found to Lorenzo the Magnificent. John R. Spencer, "Volterra, 1466," *Art Bulletin* 48, no. 1 (March 1966), pp. 95–96, has published a letter by the Humanist Antonio da Sarzana mentioning the finding of Etruscan artifacts, including "several partly broken clay vases" in a cave in Volterra in 1466.

54. Much has been read into the presence of these two dogs; see Marilyn Aronberg Lavin, "L'affresco di Piero della Francesca raffigurante Sigismondo Pandolfo Malatesta di fronte a San Sigismondo: ΘΕΩΙ ΑΘΑΝΑΤΩΙ ΚΑΙ ΤΗΙ ΠΟΛΕΙ," in *Piero della Francesca a Rimini: L'affresco nel Tempio Malatestiano*, exh. cat., Sala delle Colonne, Rimini (Bologna, 1984), pp. 3–74, for a particularly detailed interpretation, though we may wonder whether the fresco can ever have been quite so freighted with recondite meaning.

55. Piero's fascination with shadows is evident not only in those cast by the beams of the ceiling of Pilate's pretorium in the *Flagellation*, but by the shadow cast by the foreground angel in the altarpiece in Williamstown. It is with these two works in mind that the shadow cast by Saint Jerome onto the ground and the support of the bench can be seen as a possible perspectival demonstration of the projection of shadows.

This is not a subject treated in Piero's treatise on perspective, and the question is whether, like Dürer, he applied the science of perspective to cast shadows or whether the careful mapping of shadows is empirical. See Thomas Da Costa Kaufmann, "The Perspective of Shadows: The History of the Theory of Shadow Projection," *Journal of the Warburg and Courtauld Institutes* 38 (1975), pp. 258–87, especially pp. 273–75.

56. It is worth noting here the conflicting discussion about his costume, which Lightbown, *Piero della Francesca* (see note 20 above), p. 79, identifies as a Venetian "*toga*, or *dogalina a comeo*" and which he distinguishes from the Florentine *lucco* worn by a kneeling male figure in Piero's Madonna of Mercy. Whether such a clear-cut distinction can be made, I am dubious. However, Jane Bridgeman, "'Troppo belli e troppo eccellenti': Observations on Dress in the Work of Piero della Francesca," in *The Cambridge Companion to Piero della Francesca*, ed. Jeryldene Wood (Cambridge, 2002), p. 87, makes it quite clear that the scarlet strip of cloth that can be seen hanging over his shoulder and then resting on the ground in front of him is a *becchetto* — the streamer that allowed men to drape their rolled hood, or *capuccio*, over their shoulder rather than on their head. It quite clearly has nothing to do with the ermine lined hat worn by a bystander in Piero's fresco of the meeting of Solomon and Sheba — a *pileus rotundus* that identifies the wearer as a graduate of law or medicine (Bridgeman, "'Troppo belli e troppo eccellenti,'" pp. 79–80). As Anna Pizzati points out in her contribution to this catalogue, Girolamo's grandfather owned two *pelande gardinalesche*.

57. Vasari in fact tells us that "Usò assai Piero di far modelli di terra, et a quelli metter sopra panni molli con infinità di pieghe per ritrarli e servirsene" ("Piero made many models in clay, which he draped with damp cloth arranged with countless folds, to work from and use"); Vasari, *Le vite*, ed. Bettarini and Barocchi (see note 21 above), vol. 3, p. 264. He does not mention the projection of shadows, but it was clearly an interest of Piero's.

58. Piero retained the use of ligatures in his signature that were typical of the medieval tradition of epigraphy. On the history of Roman epigraphic letters in Renaissance painting, see Dario A. Covi, *The Inscription in Fifteenth Century Florentine Painting* (New York, 1986), pp. 261–76. Of Piero's Montefeltro portraits, Covi commented that "the presence of the round *E* and of two different kinds of *M* in an inscription that otherwise seems totally classical in character . . . is indeed astounding" (p. 270). The anomalies would be even more astonishing if the portraits were to date as late as many scholars have placed them — after 1472 — when an archaeologically correct form of Roman letters had been widely adopted and was, indeed, used for the inscription in the courtyard of the Ducal Palace. The classic article on this form of lettering, which has its origin in the Humanist circle of Mantegna in Padua, is that of Millard Meiss, "Toward a More Comprehensive Renaissance Palaeography," *Art Bulletin* 42, no. 2 (June 1960), pp. 97–112, reprinted in Millard Meiss, *The Painter's Choice: Problems in the Interpretation of Renaissance Art* (New York, 1976), pp. 151–75.

59. See the facsimile edition published by Broude International Editions (New York, 1992), with a bibliographical note by

Jane Andrews Aiken, Liana De Girolami Cheney, and Leonardo Farinelli.

60. For a full discussion of the documentary evidence, see Anna Pizzati, "The Family of Girolamo Amadi," in this catalogue.

61. Girolamo's wives were Elisabetta Tedaldini and Elisabetta Ridolfi. According to Calore, "Piero della Francesca e Girolamo Amadi" (see note 52 above), pp. 23–24, the marriage to Elisabetta Tedaldini took place in Sansepolcro, and she supposes that it was there that Piero painted the picture of Amadi. She does not cite evidence of this statement. Indeed, the usefulness of her article, though filled with fascinating information, is compromised by the mixture of conjecture with fact. For a masterful discussion of the picture, see Marinelli, "Piero della Francesca e la pittura veneta" (see note 46 above), pp. 444–48. Like so many Lucchese in Venice, Giovanni and Antonio Ridolfi were in the silk trade; see Luca Molà, *La comunità dei lucchesi a Venezia: Immigrazione e industria della seta nel tardo Medioevo* (Venice, 1994), p. 268.

62. See Emmanuele Antonio Cicogna, *Delle inscrizioni veneziane*, vol. 6, pt. 2 (Venice, 1853), pp. 5682–84.

63. Most recently by Calore, "Piero della Francesca e Girolamo Amadi" (see note 52 above), p. 22, who on the basis of this identification goes on to construct a hypothetical scenario for the commission.

64. Philippe Braunstein, "Relations d'affaires entre Nurembergeois et Vénitiens à la fin du XIVe siècle," *Mélanges d'archéologie et d'histoire* (École Française de Rome) 76, no. 1 (1964), p. 255, n. 2, where the cities mentioned are Venice, Florence, Bologna, and Ancona, the last being a major port of entrance for silk from the Middle East.

65. The extreme case is that of Carlo Ginzburg, *Indagini su Piero: Il Battesimo, il ciclo di Arezzo, la Flagellazione di Urbino* (Turin, 1981), pp. 63–64, who believed the supplicant of the Venice Saint Jerome is shown kneeling beneath the Madonna of Mercy and reappears as the patrician who wears a blue brocade in the Flagellation and as a bystander in the scene of the execution of Chosroes in the Arezzo cycle. He identified this person as a member of the Bacci family, who were instrumental in financing Piero's work at Arezzo. Battisti, *Piero della Francesca* (see note 29 above), pp. 518–19, rehearses in exhausting detail the various arguments for and against the identification of the person in the Venice picture with Girolamo Amadi and for and against his identification with a member of the Pichi family in Sansepolcro. See also Maria Cristina Castelli in *Piero e Urbino, Piero e le corti rinascimentali*, ed. Paolo Dal Poggetto, exh. cat., Palazzo Ducale and Oratorio di San Giovanni Battista, Urbino (Venice, 1992), pp. 111–12, who remained uncertain about who is shown. The identification of the figure with Girolamo Amadi is insisted upon by Lightbown, *Piero della Francesca* (see note 20 above), pp. 79–81, and accepted as well as by Marilyn Aronberg Lavin, *Piero della Francesca* (London, 2002), pp. 51–54, who also gives a good description of the visual dynamics of the picture. See also Marinelli, "Piero della Francesca e la pittura veneta" (see note 46 above), pp. 444–48; and Anna Pizzati, "The Family of Girolamo Amadi," page 93, note 46, in this catalogue for a possible relationship between the Amadi and the Graziani of Sansepolcro.

66. Angelini, "Dittico dei Montefeltro di Piero della Francesca" (see note 4 above), pp. 59–72, recently has made a strong case for dating the Uffizi diptych about 1462–63. The concentration of works now assigned to Piero in the 1460s would have required him to take on a number of assistants, which his paintings for Sansepolcro and Perugia suggest was, in fact, the case. For a compelling argument dating the Brera Altarpiece to the 1460s, see Emanuela Daffra in *From Filippo Lippi to Piero della Francesca: Fra Carnevale and the Making of a Renaissance Master*, ed. Keith Christiansen, exh. cat., Pinacoteca di Brera, Milan, and The Metropolitan Museum of Art, New York (New York and Milan, 2005), pp. 267–71. Daffra has compiled a useful survey of the historiography of the altarpiece in *La Pala di San Bernardino di Piero della Francesca: Nuovi studi oltre il restauro*, ed. Emanuela Daffra and Filippo Trevisani, Quaderni di Brera 9 (Florence, 1997), pp. 97–113.

67. Daniel Russo, *Saint Jérôme en Italie: Étude d'iconographie et de spiritualité (XIIIe–XVe siècle)* (Paris, 1987), pp. 221–23, notes that the particular iconography of Saint Jerome as ascetic scholar became particularly popular in Venice. Among the pictures he discusses, one in particular seems relevant for its combination of the saint and donor, though Jerome is shown in prayer rather than interrupted while reading: a panel from Carpaccio's polyptych in Zara. However, if the combination of donor and saint recalls Piero's devotional panel, the primary influence is unquestionably Bellini's Saint Francis in the Frick Collection, New York.

68. Bartolomeo Fazio, historian and secretary to Alfonso of Aragon in Naples, has left us descriptions of a triptych painted by Rogier for Leonello d'Este, who ordered works from the artist through an agent in Bruges, as well as one of the "noble pictures" by van Eyck in the collection of Federico da Montefeltro's kinsman and counselor Ottaviano Ubaldini della Carda; Alessandro Sforza, the ruler of Pesaro, owned *Giotto and the Orators* (see note 38 above), pp. 106–8, 165–67. For an overview of the literature on the subject of Netherlandish painting and Piero, see Bert W. Meijer, "Piero and the North," in *Piero della Francesca and His Legacy*, ed. M. A. Lavin (see note 10 above), pp. 143–59. Bertelli, "Piero da Perugia a Roma" (see note 25 above), pp. 34–39, summarizes the effects of Piero's presence in Ferrara.

69. Angelini, "Dittico dei Montefeltro di Piero della Francesca" (see note 4 above), p. 69.

70. The comparison between the two is made, for example, by Anna Maria Maetzke, *Piero della Francesca* (Cinisello Balsamo, 1998), pp. 78–81.

71. The importance of the tondo for Piero's work is underscored by Romano, *Il coro di San Lorenzo* (see note 21 above), p. 13. Here, it should be noted that there has evolved a misplaced and reductive tendency among art historians to ascribe every advance in naturalistic description in Italian painting to some Netherlandish source, whereas the dialogue was far more open and fluid and predicated on a common desire to achieve an effect of verisimilitude. What makes Domenico Veneziano's tondo so singularly important is the way it combines a north Italian interest in the detailed description of individual plants and animals — such as we find in the work of Pisanello — with a mathematical conception of space.

72. It is worth pointing out the difference between the land-scape in Piero's Saint Jerome and the very Eyckian one in Giovanni Boccati's Crucifixion in the Franchetti Collection of the Ca' d'Oro, Venice. In its early stages, Boccati's career follows a trajectory notably similar to that of Piero, whose work in Urbino his own reflects, albeit always in a highly eccentric and distinctly nonrational mode. See Mauro Minardi, "Giovanni di Pieromatteo Boccati," in *Pittori a Camerino nel Quattrocento*, ed. Andrea De Marchi (Jesi, 2002), pp. 206–11.

73. For a detailed history of the picture and its association with Giovanni della Rovere as well as information relating to its conservation and technique, see the various contributions in *La luce e il mistero: La Madonna di Senigallia nella sua città; il capolavoro di Piero della Francesca dopo il restauro*, ed. Gabrielle Barucca, exh. cat., Rocca Roveresca, Senigallia (Ancona, 2011). The picture is first mentioned in 1822, by Luigi Pungileoni in a letter to the Marchese Raimondo Antaldi, when it was in a chapel of the church of Santa Maria delle Grazie in Senigallia.

74. Longhi, *Piero della Francesca* (1975 ed.; see note 5 above), p. 91.

75. The case for a late date—about 1480—and its commission for Giovanni and Giovanna della Rovere is argued by Lightbown, *Piero della Francesca* (see note 20 above), pp. 257–62.

76. Perhaps most pertinent is the case of a panel by Giovanni Bellini of the Madonna and Child that in 1485—perhaps two decades after it was painted—was placed over the chapel of its owner, Luca Navagero, in the church of the Madonna dell'Orto in Venice. See Keith Christiansen, "Giovanni Bellini and the Practice of Devotional Painting," in *Giovanni Bellini and the Art of Devotion*, ed. Ronda Kasl (Indianapolis, 2004), p. 11, with bibliographical references. For the history of the Santa Maria delle Grazie in Senigallia and Giovanni della Rovere's association with it, see Francesco Benelli, "La chiesa e il convento di Santa Maria delle Grazie a Senigallia," in *La luce e il mistero* (see note 73 above), pp. 77–80. Giovanni had private quarters constructed next to the sanctuary so that through a window, he could see the altar.

77. *Filium dilectissimum* is how Ferdinand of Aragon referred to Giovanni's relationship with Federico; cited by Francesco Benelli, "Baccio Pontelli e Francesco di Giorgio: Alcuni confronti fra rocche, chiese, cappelle e palazzi," in *Francesco di Giorgio alla corte di Federico da Montefeltro: Atti del Convegno Internazionale di Studi, Urbino, monastero di Santa Chiara, 11–13 ottobre 2001*, ed. Francesco Paolo Fiore (Florence, 2004), p. 526.

78. For a fine survey of Piero's association with the court, see Daffra, "Urbino e Piero della Francesca" (see note 48 above), pp. 53–67. I find her arguments completely convincing.

79. For a survey of Justus's activity in Italy, see Mark L. Evans, "'Uno maestro solenne': Joos van Wassenhove in Italy," *Nederlands kunsthistorisch jaarboek* 44 (1993), pp. 75–110.

80. See Fernando Marías and Felipe Pereda, "Petrus Hispanus en Urbino y el Bastón del *Gonfaloniere*: El problema Pedro Berruguete en Italia y la historiografía española," *Archivo español de arte* 75 (October–December 2002), pp. 361–80; and Fernando Marías and Felipe Pereda, "*Petrus Hispanus* pittore in Urbino," in *Francesco di Giorgio*, ed. Fiore (see note 77 above), pp. 249–67.

81. For an overview of the very complex bibliography relating to this work, see the entry by Keith Christiansen in *The Renaissance Portrait from Donatello to Bellini*, ed. Keith Christiansen and Stefan Weppelmann, exh. cat., Bode-Museum, Berlin, and The Metropolitan Museum of Art, New York (New York, 2011), pp. 287–90, no. 120.

82. See Arturo Calzona, "Leon Battista Alberti e Luciano Laurana: Da Mantova a Urbino o da Urbino a Mantova?," in *Francesco di Giorgio*, ed. Fiore (see note 77 above), pp. 433–92, for evidence that during these years, the palace was being planned and both Luciano Laurana and Alberti were in Urbino. Matteo Ceriana, "Sull'architettura dipinta della pala," in *La Pala di San Bernardino*, ed. Daffra and Trevisani (see note 66 above), pp. 132–46, reviews the architectural sources for Piero's work and the importance of his presence in Urbino alongside Laurana and Alberti.

83. Vespasiano da Bisticci, *The Vespasiano Memoirs: Lives of Illustrious Men of the XVth Century*, trans. William George and Emily Waters (1926; repr., Toronto, 1997), p. 100.

84. See Calzona, "Leon Battista Alberti e Luciano Laurana" (see note 82 above), pp. 433–92.

85. Although the first written notice of the picture in Urbino dates only from the eighteenth century, when it was in a room of the sacristy of the cathedral, its presence in the city can be traced to at least the sixteenth century, since in 1578, the idealized features of the center discussant served as the model for a portrait of Federico's predecessor, Oddantonio da Montefeltro, in a portrait now at Ambras; see Daffra, "Urbino e Piero della Francesca" (see note 48 above), p. 57.

86. The date of the portraits has been much discussed, but the normal occasion for commissioning works of this sort was the commemoration of a marriage (Federico and Battista were married in February 1460). Moreover, the Carmelite friar Giovanni Andrea Ferrabò wrote an epigram in praise of a portrait of Federico by Piero that he admired when he was in the city in 1464–65, and although the identification of the work he praises with the Uffizi diptych has been contested, there is no compelling reason to do so. Lina Bolzoni, *Poesia e ritratto nel Rinascimento* (Rome, 2008), pp. 45–46, 151–53, discusses Ferrabò's poem, and in *Il cuore di cristallo: Ragionamenti d'amore, poesia e ritratto nel Rinascimento* (Turin, 2010), pp. 236–41, she also analyzes the inscriptions on the pictures. It has been argued often that since Ferrabò does not mention the portrait of Battista Sforza, he cannot be referring to the diptych, but this is an overly reductive understanding of the function and dynamics of the poem, which sets up a parallel of Piero's mimetic gifts—equal to those of the ancients—with the divine spirit of the prince that animates his likeness. The presence or not of Battista was irrelevant to Ferrabò's panegyrics. Similarly, in the inscriptions, her place is defined as that of an ideal consort. The recent analysis and early dating of the portraits proposed by Angelini, "Dittico dei Montefeltro di Piero della Francesca" (see note 4 above), pp. 59–72, is worthy of serious consideration.

87. The picture had the remarkable subject of women emerging from their bath, illuminated by a lantern. For Fazio's description, see Baxandall, *Giotto and the Orators* (see note 38 above), p. 107. The common association of Piero's portraits with those of Memling is certainly incorrect, not only

because of the question of date but because the landscape in the Uffizi diptych is distinctly Eyckian in conception and Eyckian in its atmospheric quality. As noted by Angelini, "Dittico dei Montefeltro di Piero della Francesca" (see note 4 above), p. 69, there is none of the green glades and overlapping hills that are the defining traits of Memling's landscapes and that had such a broad and recognizable impact in Florence and Venice.

88. The Annunciation from the pinnacle of Piero's altarpiece for the convent of Sant'Antonio in Perugia, which was completed by 1468, provides a closely analogous approach to the problem of figural scale and architectural setting. If anything, perspective is more conspicuously emphasized by the introduction at the center of the composition of an enfilade of columns viewed in steep recession, the cast shadow prominently displayed on the pink marble pavement. Both the Perugia Altarpiece and Piero's polyptych for Sant'Agostino in Sansepolcro, completed in 1469, seem closely related in style and complexity of design to the pictures Piero painted for the court at Urbino and thus add further weight to the idea that Piero's work for the court was concentrated in the 1460s and that, moreover, it was the culture of Federico's court at Urbino that had a transforming effect on Piero's work—not unlike his experience in Florence in 1439–40. One might note in the surviving panels from the polyptych for Sant'Agostino, beyond the architectural style of the inlaid marble balustrade before which the saints stand, that quality of largeness of form combined with meticulously observed details and the optical effects of light playing on different surfaces, whether the crystal crozier of Saint Augustine and the jewels that decorate the armor of Saint Michael or the reflected light on the hands and underside of the book of Saint John that we find as well in the Montefeltro Altarpiece.

89. Pope-Hennessy, *Piero della Francesca Trail* (see note 3 above), p. 60.

90. Joseph Archer Crowe and Giovanni Battista Cavalcaselle, *A History of Painting in Italy from the Second to the Fourteenth Century*, vol. 2 (London, 1864), p. 551. Interestingly, Crowe and Cavalcaselle thought the figure types close to those in the Perugia Altarpiece, in which they describe the child as not pleasing "in its nakedness because of its excessive fatness and the ugliness of its type" (pp. 550–51), which reminds us how much taste in beauty changes.

91. Clark, *Piero della Francesca* (see note 28 above), p. 47.

92. For the restoration, see Costanza Mora, Albertina Soavi, and Francesca Fumelli, "Il restauro e la tecnica di esecuzione," in *La luce e il mistero* (see note 73 above), pp. 105–15.

93. Hans Belting, *Likeness and Presence: A History of the Image before the Era of Art* (Chicago, 1994), pp. 337–43.

94. Ibid. The related document is reprinted in *Melozzo da Forlì*, ed. Benati, Natale, and Paolucci (see note 35 above), p. 361. Bessarion was in touch with Federico's court as early as 1465 and stopped in Urbino in 1472 to christen the newborn Guidobaldo. He is among the famous men whose images decorated the *studiolo* in the Ducal Palace.

95. Belting, *Likeness and Presence* (see note 93 above), pp. 390, 397, notes this same gesture in a *Maestà* by Coppo da Marcovaldo in the church of Santa Maria dei Servi in Siena.

96. For two recent, quite different iconographic readings of the Senigallia *Madonna and Child*, see M. A. Lavin, *Piero della Francesca* (see note 65 above), pp. 288–91; and Marinella Bonvini Mazzanti, "E se . . . Lettura storica della simbologia nella *Madonna di Senigallia*," in *La luce e il mistero* (see note 73 above), pp. 37–43. The latter assumes a personal meaning for Giovanni della Rovere.

97. Milan, Biblioteca Ambrosiana, *De prospetiva pingendi*, codex C. 307 inf., fol. 41v; illustrated in Carlo Bertelli, "Scritti di Piero della Francesca," in *Piero della Francesca e le corti italiane*, ed. Bertelli and Paolucci (see note 14 above), p. 78.

98. Sabba da Castiglione, *Ricordi, overo ammaestramenti . . .* (Venice, 1549), Ricordo no. 109; cited in Battisti, *Piero della Francesca* (see note 29 above), p. 640.

99. See Jacopo Russo, "La restituzione prospettica," in *La luce e il mistero* (see note 73 above), pp. 145–47.

100. See Millard Meiss, "Light as Form and Symbol in Some Fifteenth-Century Paintings," *Art Bulletin* 27, no. 3 (September 1945), pp. 179–81, for an exposition of the various texts associating light with the Virgin and the miracle of the Incarnation.

101. Baxandall, *Giotto and the Orators* (see note 38 above), p. 106.

102. Shearman, "Refraction, and Reflection" (see note 42 above), p. 220.

THE FAMILY OF GIROLAMO AMADI
A LUCCHESE SILK MERCHANT IN VENICE

BY ANNA PIZZATI

The Sources: *Cronaca Amadi, Cathalogus Amadi*, and *Venete famiglie cittadinesche*

Several of the available sources regarding the Amadi family go back to the sixteenth century. The first of these, the *Cronaca Amadi*, was written in the 1490s by Angelo di Giovanni Amadi, and continued in the 1530s by his kinsman Francesco di Agostino. An eighteenth-century copy of the original manuscript exists in the Biblioteca del Museo Civico Correr in Venice, *Manoscritto Gradenigo Dolfin 56* (hereafter *Cronaca Amadi*); it has been published in *Family Memoirs from Venice (15th – 17th Centuries)*, ed. James S. Grubb, with a contribution by Anna Bellavitis (Rome, 2009), pp. 1–65. The first part of the *Cronaca* (fols. 1–34), which was written by Angelo Amadi and speaks of the foundation of the church of the Miracoli, has also been published in *Santa María dei Miracoli a Venezia: La storia, la fabbrica, i restauri*, ed. Mario Piana and Wolfgang Wolters (Venice, 2003), pp. 385–94. The two writers of the *Cronaca* belonged to two different branches of the Amadi family descended from the brothers Francesco and Amato; see the family genealogical chart illustrated on page 64. The second of these sources is the *Cathalogus Amadi*, comprising some manuscript sheets included in the compendium titled "Miscellanea di cose riguardanti Padova," probably compiled in the mid-sixteenth century, which has come down to us in a mid-seventeenth-century transcription (Padua, Biblioteca Civica, MS B.P. 149/3, "Miscellanea di cose riguardanti Padova," *Cathalogus illustrium virorum familiae Amadi item mulierum de Lucana civitatis Etruriae in família Amadi desponsatae* [hereafter *Cathalogus Amadi*], fols. 345–48v). Toward the end of these sheets (fol. 348v), the following statement is made: "Queste memorie della casa Amadi sono state fedelmente copiate, et con gli stessi errori che si trovano scritte, da un libretto che s'attrova appresso la signora Lucietta [Penguinazzi] già moglie del quondam signor Pietro Amati et hora del signor Matteo [Cortuso] che sta agli Heremitani. Laus Deo 1650, 20 dicembre." The third source is the manuscript *Venete famiglie cittadinesche*, written by several hands and with some passages attributed to the scholar Emmanuele Antonio Cicogna to the sixteenth-century genealogist Marco Barbaro (Venice, Biblioteca del Museo Civico Correr, MS *Cicogna* 2156, fols. 17–34), which may be read alongside another manuscript about families in the city of Venice, with a similar account (Venice, Biblioteca del Museo Civico Correr, MS *Gradenigo Dolfin* 83, fols. 11–15). On comparing these sources with material drawn from the Venice State Archives, it can be said that the number of errors in these three sources is very high but that there is also a good deal of correct information. Yet it is very hard to make a distinction between what ought to be kept and what can be discarded. After much uncertainty, a cautious approach has been adopted, citing only what can be backed up by archival documents, especially when this regards information relating to periods far removed from the mid-1500s, at which point a "history" of the Amadi was formulated. Emmanuele Antonio Cicogna himself called for prudence in the *Delle inscrizioni veneziane*. Having cited a lengthy

passage about the Amadi from the *Venete famiglie cittadinesche*, and having noted much erroneous information, the great *erudito* remarked that "Whoever consults the aforementioned Cronica Cittadinesca about other individuals of the Amadi lineage should exert caution in sifting through the material because there are not a few errors of date, person's name, and family name" (Emmanuele Antonio Cicogna, *Delle inscrizioni veneziane*, vol. 6, pt. 1 [Venice, 1853], p. 385).

1. Venice, Archivio di Stato (hereafter ASVe), *Commemoriali*, reg. 1, fol. 32, undated [1303]; Riccardo Predelli, *I libri commemoriali della Repubblica di Venezia: Regesti*, 8 vols. (Venice, 1876–1914), vol. 1 (1876), p. 34, no. 147. It is hard to make any connection between our Amadi and *Petrus Amado*, a witness in a contract of 1167; see Raimondo Morozzo Della Rocca and Antonino Lombardo, *Documenti del commercio veneziano nei secoli XI – XIII* (Turin, 1940), vol. 1, p. 178.

2. Emmanuele Antonio Cicogna, *Delle inscrizioni veneziane*, 6 vols. (Venice, 1824–53), vol. 6, pt. 1 (1853), p. 376.

3. It is interesting to read what Benedetto Arborsani had to say about this in the mid-sixteenth century; see "De la anticha prole e aricordi di Beneto Arbusani el terzo 1543 a li posteri e sucesori de lui disesi," in *Family Memoirs from Venice (15th – 17th Centuries)*, ed. James S. Grubb, with a contribution by Anna Bellavitis (Rome, 2009), pp. 76–79. See also Telesforo Bini, *I Lucchesi a Venezia*, 2 vols. (Lucca, 1853); and the fundamental study by Luca Molà, *La comunità dei lucchesi a Venezia: Immigrazione e industria della seta nel tardo Medioevo* (Venice, 1994), pp. 26–30.

4. Testament of November 7, 1350; ASVe, *Notarile, Testamenti*, busta (hereafter b.) 1023, no. 8 (notary Pietro Cavazza).

5. In 1361, Michele was *guardiano* of the confraternity of San Giovanni Battista in Murano, according to the inscription published by Cicogna, *Delle inscrizioni veneziane* (see note 2 above), vol. 6, pt. 1, p. 376. By the mid-1300s, the professional profile of a dyer was already clearly defined, since dyeing was a particularly delicate phase of silk production, involving notable skills and confidentiality. Secrets were passed from father to son, together with the management of the workshop, and in order to protect their interests, Venetian dyers formed a corporation in the fourteenth century. See Molà, *La comunità dei lucchesi* (see note 3 above), pp. 155–67; and Luca Molà, "The Italian Silk Industry during the Renaissance," in *Le mariegole delle arti dei tessitori di seta: I veluderi (1347 – 1474) e i samitari (1370 – 1475)*, ed. Simone Rauch (Venice, 2009), pp. LXVI – LXXIII.

6. Giacomina's will is in ASVe, *Notarile, Testamenti*, b. 1023, no. 66 (notary Pietro Cavazza), September [6], 1349; for Francesca's, see ASVe, *Notarile, Testamenti*, b. 1023, no. 126, January 17 or 18, 1358.

7. The figure comes from an official request made by Giovanni Amadi in 1369; see *Cassiere della bolla ducale: Grazie, registro n. 16*

(1364–1372), ed. Stefano Piasentini, Fonti per la storia di Venezia, Sezione I, Archivi pubblici (Venice, 2009), vol. 2, doc. no. 1410. Seven thousand *lire a grossi* in taxable estate was a medium-to-high figure: of all taxpayers (patricians and *popolani*) in the 1379–80 *estimo* (tax assessment) made on the occasion of the Chioggia war, only 15 percent were worth over 5000 lire. The percentage is even lower if the comparison is made among the *popolani* alone: only 8 percent of these were worth over 5000 lire. The present calculations are based on data published by Gino Luzzatto, *Storia economica di Venezia dall'XI al XVI secolo* (Venice, 1995), p. 117.

8. *Cassiere della bolla ducale*, ed. Piasentini (see note 7 above), vol. 2, doc. no. 1410.

9. Molà, *La comunità dei lucchesi* (see note 3 above), p. 280.

10. The arms of Ca' Amadi are cited in inventories of 1394 and 1415; ASVe, *Chiesa di Santo Stefano di Murano*, b. 1, *catastico*, fols. 5 and 13v.

11. In her will of August 7, 1382, Taddea Amadi, sister of Giovanni and wife of Luca Minio, states that Giovanni had just recently died, and she urges her executors not to claim anything from her brother's estate. ASVe, *Notarile, Testamenti*, b. 1071/3, no. 434 (notary Pietro Zonello).

12. Giovanni's wife Caterina (but the reading of her name is not certain) made her will in 1371, leaving an equal inheritance to her sons and daughters. It has not been possible to verify which family she came from. ASVe, *Cancelleria Inferiore, Notai*, b. 118, no. 10 (notary B. Miorato).

13. Giorgio, who made no less than five wills, lived in the house of his brother Amato at San Giovanni Crisostomo, and after having four times enjoined that his goods should be distributed to the poor, he stated in his last will of September 26, 1440, that his heir was to be his nephew Agostino, son of Amato. ASVe, *Cancelleria Inferiore, Miscellanea notai diversi*, b. 24, no. 1585 (August 12, 1421) and no. 1587 (August 16, 1421); ASVe, *Notarile, Testamenti*, b. 1238, no. 316 (notary Tomei, February 9, 1426), b. 385, no. 58 (notary B. Camuzzi, September 26, 1437), and b. 726, no. 101 (notary G. Moisis, September 26, 1440).

14. For the business relationship between Francesco Amadi and Lorenzo de Provenzali, see ASVe, *Procuratori di San Marco, Misti*, b. 112, *Commissaria Amadi*, parchment dated February 11, 1393. Perina also stands out, as she was chosen as executrix on several occasions. Her son Nicolò died before 1411, her daughter Teodora married Andrea Zulian, and her other daughter Apollonia married Marco Bembo. She drew up two wills, leaving her daughters as heirs; ASVe, *Notarile, Testamenti*, b. 364, no. 282 (notary Darvasio, June 4, 1411), and b. 995, *protocollo* fol. 55v (notary Marco Tagliapietra, September 23, 1427).

15. Philippe Braunstein, "Relations d'affaires entre Nurembergeois et Vénitiens à la fin du XIVe siècle," *Mélanges d'archéologie et d'histoire* (École Française de Rome) 76, no. 1 (1964), pp. 254–69. In 1396, Francesco Amadi received a power of attorney to carry out business for Hilpolt Kress; Molà, *La comunità dei lucchesi* (see note 3 above), p. 241, n. 107. The links between the Amadi and the Kress families continued with the generations that followed, with the Kress sons coming to Venice to learn the art of commerce, living in the house of one of Francesco Amadi's sons.

16. ASVe, *Procuratori di San Marco, Misti*, b. 112, *Commissaria Amadi*, parchment dated May 8, 1394.

17. The Senate's appointment is dated March 4, 1406, while a subsequent letter sent while Francesco Amadi was already on his mission dates from June 18; ASVe, *Senato, Deliberazioni, Secreta*, reg. 3, fols. 1 and 27v–28. These documents are transcribed in the *Cronaca Amadi*, in *Family Memoirs from Venice*, ed. Grubb (see note 3 above), pp. 33–35.

18. For the hospital of Santi Pietro e Paolo, see ASVe, *Commemoriali*, reg. 7, fol. 94 (91); and Predelli, *I libri commemoriali* (see note 1 above), vol. 3 (1883), p. 123, no. 797 (misprinted as 1500 instead of 1400). For the Scuola di San Giovanni Evangelista, see Alessandra Schiavon, "Santa Maria dei Miracoli: Una fabbrica 'cittadina,'" in *Santa Maria dei Miracoli a Venezia: La storia, la fabbrica, i restauri*, ed. Mario Piana and Wolfgang Wolters (Venice, 2003), p. 3, n. 4. In their wills, both Francesco and Amato state their membership in the confraternity.

19. *La cronaca della Certosa del Montello*, ed. Maria Luisa Crovato (Padua, 1987), pp. 105–6, 111; the episode is also cited in Cicogna, *Delle inscrizioni veneziane* (see note 2 above), vol. 6, pt. I, p. 385.

20. This document is important because it provides the firm link between Checco's son Giovanni, the dyer (claimed as bishop and cardinal in family chronicles), and his children and heirs Francesco, Amato, Perina, and Giorgio. When the Murano estate was divided, Francesco bought out Giorgio's share. ASVe, *Cancelleria Inferiore, Notai*, b. 173, parchment no. 18 (notary F. Rizzotto).

21. According to a document of 1393, Francesco was resident in San Canciano, whereas in 1401, he lived in Santa Marina. ASVe, *Procuratori di San Marco, Misti*, b. 112, parchment dated February 11, 1393; ASVe, *Signori di Notte al Criminale, Processi*, reg. 12, fol. 70v, December 20, 1401.

22. The will, which is in Francesco Amadi's hand, is in ASVe, *Cancelleria Inferiore, Miscellanea notai diversi*, b. 1, file marked with the date January 2, 1405 (Venetian style).

23. The property line bordered the Palazzo Morosini on one side and Ca' Zen on the Grand Canal side. There was a lawsuit with the latter, because the Amadi had adjoining windows made, and these were contested by the Zen; the case was first brought before the *Corte dell'Esaminador* and then resolved by the *Avogadori di Comun*, and the Amadi succeeded in demonstrating that the officer who had described the property lines had admitted that he forgot to include the clause that allowed windows to be opened. ASVe, *Cancelleria Inferiore, Notai*, b. 207, fragmentary, unnumbered, and much ruined register of records, under September 19 [1408]; and ASVe, *Avogaria di Comun*, reg. 3646 (Raspe, reg. 6), fols. 66v–67, September 11, 1409.

24. This can be deduced from the agreement between the Amadi brothers and Giorgio Troncon; ASVe, *Cancelleria Inferiore, Notai*, b. 227, fols. 110v–111 (notary Angeletto da Venezia, March 1, 1413).

25. In 1413, Giorgio Troncon, Zanino's "bad" brother who owed money to Amato, declared before a notary that he would not upset his father's estate (being content with the interest from the 1000 ducats of forced loans he had inherited); that he would accept the terms of his brother's estate, namely

further interest from 1500 ducats of loans; and that his heir would be his nephew Bartolomeo, the son of Zanino and Gasparina (who was by now the wife of Amato Amadi). Amato had Giorgio Troncon released from prison, standing as his guarantor and paying the 308 lire penalty imposed on him by the *Cinque anziani alla pace*; ASVe, *Cancelleria Inferiore, Notai,* b. 227, fols. 42r–v (notary Angeletto da Venezia).

26. According to family tradition, it was in this house (in San Canciano, not Santa Marina, as Cicogna states) that the Amadi hosted Emperor Frederick III when he came to Venice in 1452; see Cicogna, *Delle inscrizioni veneziane* (see note 2 above), vol. 6, pt. 1, p. 385. A description of the property, although it had been in Amadi hands for some generations, is in ASVe, *Giudici dell'Esaminador, Vendizioni, alienazioni, donazioni,* reg. 19, fols. 82v–84, March 10, 1511.

27. For the residence in Santa Croce, see below in the text, "The Descendants."

28. She left her sons and daughters as her heirs in equal parts, and entrusted her husband, to whom she left a bequest of 100 ducats, with the task of executing her will; ASVe, *Cancelleria Inferiore, Notai,* b. 94, no. 1, fol. 6v (notary Michele Gorgorati, January 12, 1409).

29. The *Venete famiglie cittadinesche* and the *Cathalogus Amadi* recount that in 1384, Amato married Gasparina Condulmer, niece of Pope Eugenius IV and kinswoman of Gregory XII, while archival documents reveal that Amato married Agnesina (probably around 1384, as she was about twenty at that time), and immediately after her death in 1409, Troncon's widow Gasparina. Unfortunately, neither of the wills of both of Amato's wives state their families of origin.

30. We know the year of Agostino's birth, 1410, thanks to a declaration made by the parish priest of San Giovanni Crisostomo, Marco Tagliapietra, who was also one of the Amadi family notaries: he stated on June 27, 1425, that he had arrived in that parish fifteen years before, and that in the course of his first year, he had baptized Agostino; ASVe, *Procuratori di San Marco, Misti,* b. 112, loose parchment. From Gasparina's will, we can tell that Agostino was her son; ASVe, *Notarile, Testamenti,* b. 726, no. 103, and *protocollo* fol. 20, no. 36 (notary G. Moisis, November 24, 1449).

31. Of the four daughters, three were already married (Maria with a Barbarigo, Filippa with Nicolò Bon, and Polissena with Giovanni Natali), and only Perina remained unmarried. To her, Amato left a dowry of 2400 ducats, which was then revised to 2000. Amato's will is in ASVe, *Notarile, Testamenti,* b. 995, *protocollo* fol. 33 (notary Marco Tagliapietra, June 19, 1422); a copy is in ASVe, *Procuratori di San Marco, Misti,* b. 112, parchment.

32. Shortly before he died, Francesco urged that his unmarried daughter Graziosa should marry a patrician ("sia maridada in lo Conseio de Veniexia"). For Amato's will, see note 31 above. For Francesco's will, see ASVe, *Notarile, Testamenti,* b. 1233, no. 237 (notary F. de Soris, December 30, 1424); an earlier will of his is in ASVe, *Cancelleria Inferiore, Notai,* b. 227, fol. 43 (notary A. da Venezia, January 14, 1413). The will reveals Francesco's strong respect for his oldest son, Giovanni, who was married to Paoluccia di Fantino Pisani and was sent by the Republic of Venice on a diplomatic mission to Lucerne in 1426, with the task of creating an alliance with the Swiss cities against the Visconti Dukes of Milan. For an analysis of these documents, see Anna Pizzati, "Venezia," in *Gentile da Fabriano: Studi e ricerche,* ed. Andrea De Marchi, Laura Laureati, and Lorenza Mochi Onori (Milan, 2006), p. 106.

33. This suggestion is supported by the description of the *pellanda*—an ample outer garment, trimmed with fur, sometimes with a hood aligned with the rest of it and worn without a belt up to the beginning of the 1400s, and later belted at the waist—given by Achille Vitali, *La moda a Venezia attraverso i secoli: Lessico ragionato* (Venice, 1992), pp. 278–80. The inventory was drawn up before his widow Gasparina, his sister Perina de Provenzali, his nephew Giovanni (the son of Francesco), and his children Girolamo and Polissena. The items included "una capa beretina da galia fodrà de tella [. . .] una pellanda gardanelesca da homo [. . .] 1 pellanda gardenalesca ugnola [. . .] 1 mantello gardenalesco nuovo." ASVe, *Procuratori di San Marco, Misti,* b. 112, *Commissaria Amadi,* loose parchment, December 2, 1424.

34. Benedetto was married first to Antonia Bonifacio, and then to Elisabetta, the widow of a member of the Nani family. Having left his father's household, he moved to the *sestiere* of Santa Croce, by the Tolentini, where another notable Amadi residence was established. This property was sold subsequently to the descendants of Agostino, Benedetto's brother, who built a palazzo renowned in the mid-sixteenth century; see below in the text, "The Descendants." For Benedetto and his *terraferma* properties in the *podesteria* of Mirano, part of the dowry of his first wife, see the extensive documentation in ASVe, *Procuratori di San Marco, Misti,* b. 112, *Commissaria Amadi.*

35. He was obliged to appear before the judges of the *Procurator,* acting against the *Procuratori* of Saint Mark's, who were managing the estate; ASVe, *Procuratori di San Marco, Misti,* b. 112, *Commissaria Amadi,* parchment dated September 26, 1426.

36. ASVe, *Procuratori di San Marco, Misti,* b. 112, *Commissaria Amadi,* parchment dated July 9, 1436. The *procuratori* asked Girolamo to return the goods or pay a compensation of 95 *lire a grossi.*

37. See Elisabeth Crouzet-Pavan, *"Sopra le acque salse": Espaces, pouvoir et société à Venise à la fin du Moyen Age* (Rome, 1992), vol. 1, pp. 617–68; and *Santa Maria dei Miracoli,* ed. Piana and Wolters (see note 18 above).

38. *Cronaca Amadi,* in *Family Memoirs from Venice,* ed. Grubb (see note 3 above), p. 13.

39. Polissena's will is in ASVe, *Notarile, Testamenti,* b. 565, *cedole testamentarie,* no. 163 (notary Felice Bruno, March 18, 1445); for Francesco's share of the inheritance, see ASVe, *Giudici dell'Esaminador, Preces,* reg. 12, fols. 40v–41, May 8, 1454. Furthermore, Agostino was the sole heir of the assets of his uncle Giorgio, the brother of Francesco and Amato (will in ASVe, *Notarile, Testamenti,* b. 726, no. 101 [notary Giuseppe Moisis, September 26, 1440]), and of his mother, Gasparina (ASVe, *Notarile, Testamenti,* b. 726, no. 103, and *protocollo* fol. 20, no. 36).

40. Evidence of this marriage in the November 16, 1464, will of Paola Pescina, daughter of Silvestro, who named among her executors her paternal aunt Pellegrina (*dominam Peregrinam Amadi relicta domini Augustini amitam meam*); ASVe, *Notarile, Testamenti,* b. 985, no. 423 (notary F. Rogeri). See also

Cicogna, *Delle inscrizioni veneziane* (see note 2 above), vol. 6, pt. 2 (1853), pp. 842–43.

41. Fontana married Leonardo de Monte, and she was a widow in 1486; ASVe, *Notarile, Testamenti*, b. 955, no. 251 (notary Ludovico Talenti, August 29, 1486).

42. For Agostino's participation in the *probae*, see ASVe, *Collegio, Notatorio*, reg. 9, fol. 11v, September 23, 1453, and fol. 171, November 26–December 4, 1459. For the dating of Agostino's death, see the will of Paola Pescina (see note 40 above).

43. See the interesting considerations made by Benedetto Arborsani in "De la anticha prole e aricordi di Beneto Arbusani," in *Family Memoirs from Venice*, ed. Grubb (see note 3 above), pp. 71–81; and see also Molà, *La comunità dei lucchesi* (see note 3 above), pp. 265–71.

44. Thus Francesco di Girolamo Amadi, grandson of Amato, took part in the procession in his capacity as *guardian grande* of the Scuola della Carità; see *Cronaca Amadi*, in *Family Memoirs from Venice*, ed. Grubb (see note 3 above), p. 12.

45. We only know of Pietro's first marriage from the *Cathalogus Amadi*, fol. 348.

46. The Ridolfi had a third sister, Laura, married to Andrea Graziani (or Graziano). Each of the three sisters, who were very tight, is often mentioned in family wills, as an executrix or beneficiary of small bequests. What remains unclear is their connection with the Graziani, patricians of Borgo Sansepolcro and closely associated with Piero della Francesca; indeed a family with this last name, and with close ties to the Amadi, resided in Venice. In the 1420s, a Girolamo di Pietro Amadi was married to Isabetta Graziani. On the Graziani family of Sansepolcro, see James R. Banker, *The Culture of San Sepolcro during the Youth of Piero della Francesca* (Ann Arbor, 2003), pp. 236–42.

47. See *Cronaca Amadi*, in *Family Memoirs from Venice*, ed. Grubb (see note 3 above), pp. 40, 56–57.

48. The earliest possible date for Girolamo's death is June 1503. Francesco and his wife Paola Da Ponte had the same notary, Ludovico Talenti, draw up their wills just days apart. Paola named as her executor and sole heir her nephew Agostino, the son of Pietro Amadi. After Girolamo's death, they both (once again in quick succession) modified their wishes with a codicil. Francesco's will is in ASVe, *Notarile, Testamenti*, b. 957, *protocollo* fols. 189–90 (May 15, 1503, and codicil June 5, 1507), and the *cedole testamentarie* in ASVe, *Notarile, Testamenti*, b. 955, no. 255. For his wife Paola's will, see ASVe, *Notarile, Testamenti*, b. 956, no. 555 (May 17, 1503, and codicil June 15, 1507). See also Sergio Marinelli, "Piero della Francesca e la pittura veneta," in *Piero della Francesca tra arte e scienza: Atti del Convegno Internazionale di Studi, Arezzo, 8–11 ottobre 1992, Sansepolcro, 12 ottobre 1992*, ed. Marisa Dalai Emiliani and Valter Curzi (Venice, 1996), pp. 446–47.

49. In his *Summa de arithmetica, geometria, proportioni et proportionalità* (Venice, 1494), Luca Pacioli relates that in 1470, he had as "discipuli ser Bartolomeo e Francesco e Paulo fratelli de Rompiasi da la Zudeca, degni mercatanti in Vinegia, figliuoli già de ser Antonio, sotto la cui ombra paterna e fraterna in lor propria casa me relevai." See Bruno Nardi, *Saggi sulla cultura veneta del Quattro e Cinquecento*, ed. Paolo Mazzantini (Padua, 1971), pp. 41–42, n. 5; and Marinelli, "Piero della Francesca e la pittura veneta" (see note 48 above), p. 438.

50. After long, moralizing advice and an invitation to live according to the golden mean, Benedetto Arborsani recounts how Lucchese families arrived in Venice in the early 1300s, and reconstructs his family's history with a precision that is unfortunately lacking in both the *Cronaca Amadi* and the *Cathalogus Amadi*. He concludes with a long list of notarial deeds and family wills, starting in the mid-1300s, in his possession. See "De la anticha prole e aricordi di Beneto Arbusani," in *Family Memoirs from Venice*, ed. Grubb (see note 3 above), pp. 71–101. On Arborsani, see Cicogna, *Delle inscrizioni veneziane* (see note 2 above), vol. 1 (1824), p. 251.

51. Filippo's wills are in ASVe, *Notarile, Testamenti*, b. 41, no. 28, unpublished will, notarial deeds of Francesco Bonamico, August 24 or 26, 1490, and codicil of March 14, 1494.

52. ASVe, *Giudici di Petizion, Sentenze a giustizia*, reg. 217, fol. 127, August 25–27, 1515.

53. The account books appear in the posthumous inventory of Elena Amadi, the daughter of Girolamo, which also provides information on the family's numerous property purchases in the area around Padua in those years; ASVe, *Cancelleria Inferiore, Miscellanea notai diversi*, b. 39, no. 57, May 19, 1554. For the safe-conduct and the sequestered ship, see *Cronaca Amadi*, in *Family Memoirs from Venice*, ed. Grubb (see note 3 above), pp. 45–48, 61. A *ducale* (letter of authority from the Doge) of 1487 urged the *capitano* of Padua to proceed with pile driving to strengthen the embankments where Francesco Amadi's houses were being built, and with another *ducale* of 1495, Francesco obtained a permit to use wood destined for the Arsenal in Venice; *Cronaca Amadi*, in *Family Memoirs from Venice*, ed. Grubb, pp. 55, 57–58.

54. Marino Sanudo, *I diarii*, ed. by Federico Stefani, 58 vols. (Venice, 1879–1903), vol. 1 (1879), col. 671, under June 27, 1497.

55. Ibid., vol. 8 (1882), col. 366.

56. The episode was reported by Girolamo's children in the *condizione di decima* (tax return) of 1514, in which the property they declare includes the barren land "dove era la nostra caxa granda" by the Porta San Giovanni, with the note "la qualle per la illustrissima Signoria nostra fu bruxada et ruinada"; ASVe, *Dieci Savi alle Decime in Rialto*, Redecima 1514, b. 34, San Geremia, no. 60. Many years later, in 1597, addressing an official request to the Senate and recounting the glories of the Amadi, one of Pietro's descendants recalled the unhappy episode; ASVe, *Senato, Terra*, filza 143, under July 1, 1597.

57. One can deduce from the will of Elisabetta Tedaldini, daughter of Francesco, that she had no other children; ASVe, *Notarile, Testamenti*, b. 956, no. 650, December 9, 1490, and *protocollo* in b. 957, fols. 57v–58 (notary Ludovico Talenti). For a reconstruction of Girolamo's family tree, though with some inaccuracies, see Marinelli, "Piero della Francesca e la pittura veneta" (see note 48 above), pp. 444–47; and Andrea Calore, "Piero della Francesca and Girolamo Amadi: Chiarificazioni e aggiunte," *Bollettino del Museo Civico di Padova* 89 (2000), pp. 17–28.

58. Elisabetta was widowed at the age of twenty-three when her husband, Paolo Ciera, died, leaving her with a little boy to care for. In 1513, she wedded Sebastiano Balbi, with a marriage contract in which Balbi agreed to accept her still very young son in his home, and in exchange, she brought a dowry of 2000 ducats and the assets that pertained to the

child's inheritance; ASVe, *Avogaria di Comun*, reg. 141 (*Contratti di nozze*), fol. 50, June 18, 1513 (cited in Anna Bellavitis, *Identité, mariage, mobilité sociale: Citoyennes et citoyens à Venise au XVIe siècle* [Rome, 2001], p. 211).

59. In 1509, when she made her will, Elisabetta Ridolfi had been a widow for two years; she left equal shares of her estate to her son Domenico and two daughters Elena and Modesta. She also remembered her stepdaughter Elisabetta with a small bequest of 10 ducats. ASVe, *Notarile, Testamenti*, b. 955, no. 182, March 13, 1509 (notary Ludovico Talenti).

60. Among the few things we know about Ziliveto is that in 1493 he purchased the Amadi *casa da stazio* in the *sestiere* of Santa Croce from the heirs of Benedetto di Amato Amadi, who were in debt; the building was inherited later by Pietro di Agostino Amadi. ASVe, *Miscellanea di carte non appartenenti ad alcun archivio*, b. 1, fasc. 16.

61. 1513 saw the division of goods between Agostino and the sons of Girolamo; ASVe, *Cancelleria Inferiore, Miscellanea notai diversi*, b. 39, no. 57, May 19, 1554.

62. In fact, the *bottega* no longer existed, having been expropriated in 1505 for the building of the new Fontego dei Tedeschi, but while waiting for the assignment of a new site or remuneration of 1200 ducats, Girolamo's heirs received an annual income of 60 ducats; ASVe, *Dieci Savi alle Decime in Rialto*, Redecima 1514, b. 34, San Geremia, no. 60. See also the May 19, 1554, posthumous inventory of Elena di Girolamo Amadi in ASVe, *Cancelleria Inferiore, Miscellanea notai diversi*, b. 39, no. 57.

63. Domenico's will is in ASVe, *Notarile, Testamenti*, b. 203, *protocollo* fols. 85v–86, no. 104, and b. 201, no. 102 (notary G. Chiodo, April 9, 1519).

64. Elena's will is in ASVe, *Notarile, Testamenti*, b. 125, no. 250 (notary F. Bianco, June 14, 1553); the inventory, drawn up in the presence of both executors, her husband and her cousin Lucrezia Ridolfi, is in ASVe, *Cancelleria Inferiore, Miscellanea notai diversi*, b. 39, no. 57, bundle of 22 folios, under May 19, 1554.

65. That Agostino was a child of Pietro's first marriage can be deduced from the will of his second wife, Lucrezia Ridolfi, and since she was childless, she named as her heirs the children of her sister Elisabetta and Girolamo Amadi; ASVe, *Notarile, Testamenti*, b. 50, protocollo fols. 149v–150, no. 163 (notary Girolamo de Bossis, January 10, 1512).

66. Sanudo, *I diarii* (see note 54 above), vol. 34 (1892), col. 303, July 19, 1523. In the following year Giovanni and his wife were insulted by some Paduan shopkeepers; Sanudo, *I diarii*, vol. 35 (1892), col. 310, January 2, 1524. In 1532, Giovanni was referred to by Sanudo as "el cavalier, venitian, stà a Padoa"; Sanudo, *I diarii*, vol. 56 (1901), col. 274. The *Cathalogus Amadi*, fol. 348, states that Giovanni di Filippo was married twice, to Lucrezia di Pietro Gabrielli and Andriana Malipiero.

67. Adriano's will is in Padua, Archivio di Stato, *Archivio Notarile*, b. 4948, fols. 555–59 (January 1, 1627). In 1604, Adriano di Ferrando married Cristina Veruzzi, whose dowry was worth 6000 ducats; ASVe, *Giudici del Proprio, Vadimoni*, b. 56, reg. 169, fols. 153v–155.

68. ASVe, *Dieci Savi alle Decime in Rialto*, Redecima 1514, b. 27, San Canciano nos. 47 and 49. In 1514, Agostino is recorded as resident in the house in San Canciano, at the Biri. For the coats of arms on the houses in San Giobbe, see Alberto Rizzi, *Scultura esterna a Venezia: Corpus delle sculture erratiche all'aperto di Venezia e della sua laguna* (Venice, 1987), p. 241, no. 24.

69. On the coat of arms, see Rizzi, *Scultura esterna a Venezia* (see note 68 above), p. 409, no. 23.

70. See the *Venete famiglie cittadinesche*, fols. 25–34. The garden, library, "studio d'anticaglie," and "studio di musica" were considered among the most notable in Venice by Francesco Sansovino in his *Venetia, città nobilissima e singolare* (Venice, 1581; repr., Bergamo, 2002), pp. 137–39, which however attributes the ownership to his son Agostino. For these collections, see Francesca Pitacco, "Francesco e Agostino Amadi," in *Il collezionismo d'arte a Venezia: Dalle origini al Cinquecento*, ed. Michel Hochmann, Rosella Lauber, and Stefania Mason (Venice, 2008), pp. 250–51.

71. For the Humanist uncle, see Claudio Mutini, "Brocardo, Antonio," in *Dizionario biografico degli Italiani*, vol. 14 (Rome, 1972), pp. 283–84. On Francesco di Agostino Amadi, see Gualtiero Todini, "Amadi, Francesco," in *Dizionario biografico degli Italiani*, vol. 2 (Rome, 1960), p. 609; on Francesco as *letterato*, see Daria Perocco, "Un testo quasi sconosciuto della questione della lingua nel Cinquecento: Il *Dialogo de la lingua italiana* di Francesco Amadi," in *Studi e problemi di critica testuale* 26 (1983), pp. 117–50; and Daria Perocco, "Nuove postille e osservazioni di Francesco Amadi," in *Studi vari di lingua e letteratura italiana in onore di Giuseppe Velli*, Quaderni di Acme 41 (Milan, 2000), pp. 383–403.

72. See James S. Grubb, "Libri privati e memoria familiare: esempi dal Veneto," in *La memoria e la città: Scritture storiche tra il Medioevo ed età moderna*, ed. Claudia Bastia and Maria Bolognani (Bologna, 1995), p. 68; and James S. Grubb, "Introduction," in *Family Memoirs from Venice*, ed. Grubb (see note 3 above), pp. XI–XXIX. See also Stanley Chojnacki, "La formazione della nobiltà dopo la Serrata," in *Storia di Venezia*, vol. 3 (Rome, 1997), p. 663; and Dorit Raines, *L'Invention du mythe aristocratique: L'Image de soi du patriciat vénitien au temps de la Sérénissime* (Venice, 2006), vol. 1, pp. 405ff.

73. "Un quadro de nostra dona et un spechio grando doradi, 3 quadri de nostra donna grandi, un san Gierolamo grando, quadri de retratti grandi numero vinticinque, retratti mezani numero 18, retratti picoli numero 30"; ASVe, *Giudici del Proprio, Mobile*, b. 25, reg. 68, fols. 70r–v, May 12, 1584, with a marginal note of October 23, 1610, which indicates that in order to tackle financial problems, Agostino pawned some musical instruments, even drawing on some of the goods that belonged to his children. Pitacco, "Francesco e Agostino Amadi" (see note 70 above), pp. 250–51, writes that "A fronte di una presenza così massiccia di ritratti, appare inevitabile domandarsi se fra di essi trovasse posto anche la tavoletta di Piero della Francesca rappresentante San Girolamo e un devoto" ("Faced by such a huge number of portraits, it seems inevitable to wonder whether these might have included the little panel by Piero della Francesca with Saint Jerome and a supplicant").

74. Cicogna, *Delle inscrizioni veneziane* (see note 2 above), vol. 6, pt. 1, p. 382, believed that *Il libro delle cifre* was lost, but as pointed out by Schiavon, "Santa Maria dei Miracoli" (see note 18 above), p. 5, it is housed in ASVe, *Inquisitori di Stato*,

b. 1269. See Piero Lucchi, "Un trattato di crittografia del Cinquecento: Le zifre di Agostino Amadi," in *Matematica e cultura*, ed. Michele Emmer (Milan, 2004), pp. 39–49.

75. Agostino married Vincenza (or Cecilia) Cignoni *"dalla seda,"* and the nuptial contract dated March 23, 1566, also shows a record of the birth of their six children; ASVe, *Avogaria di Comun*, reg. 153, "Contratti di nozze," fol. 43, under March 23, 1566. With the birth in 1571 of Francesco, his eldest son, Agostino made a dower gift to his wife of 1500 ducats, "in segno d'amor che io li porto et come dal suddetto quondam mio padre mi fu comesso che così facesse havendo figlioli maschi, acciocché con amor materno quelli governi et allievi con il timor di Dio"; cited in Bellavitis, *Identité, mariage, mobilité sociale* (see note 58 above), p. 195. For the pension granted on receipt of the treatise on cyphers, see ASVe, *Avogaria di Comun*, b. 365, no. 34, March 16, 1588. Another, more meager inventory was drawn up on Agostino's death in 1588, with goods under the guardianship of the widow's dower: "Uno teller con uno retrato de ser Agustin Amai schietto; uno quadro con uno altro Amai vecchio schietto; uno quadro grando de uno sasson col teller schietto vechio; uno altro retrato del Amadi el vechio schietto; [. . .] uno quadro se una Madonna col suo teller schieto; uno quadro de uno Christo schietto vechio; uno altro quadro de uno fantolin del Amadi col teller dorado"; ASVe, *Giudici del Proprio, Mobile*, b. 28, reg. 78, fols. 6–7v, April 7, 1588.

76. "Le chiavi di esso Statuario sono state sempre appresso il secretario che mi fu deputato, messer Piero Amai, che con molta diligentia et patientia si ha travagliato meco in questo carico con piena mia sodisfattione, si come anco si adopera in molti carichi importantissimi della Serenità Vostra et ha molto meritato et merita la gratia sua." ASVe, *Commemoriali*, reg. 25, fols. 180–83 (foliation in pencil); Predelli, *I libri commemoriali* (see note 1 above), vol. 7 (1907), p. 68, nos. 95–101.

77. ASVe, *Senato, Terra*, filza 143, under July 1, 1597. The request refers to the episodes mentioned above.

78. "Retratto di Zuanne Amai vescovo di Venetia del 1379 . . ., retrato de Rinaldo Amadi vescovo faentino del 975 . . ., retrato de Amato Amadi consegiero de Carlo 4 imperatore del 1379 . . ., retrato de Giorgio Amadi vescovo del 1383 . . ., retrato de Francesco Amai imperator generale de l'esercito senese contra fiorentini del 1173 . . ., retrato de beato Bortolomeo Amai fondator della religion de Servi del 1266. . ., retrato de Eraclio Amadi re de Lonbardia del 775 . . ., retrato de Astolfo Amadi re della Lonbardia del 755 . . ., retratto di Ferando Amai . . ., retrato de Zuane Amai cavalier del 1554 . . ., retrato de Agustino Amai cavalier del 1435 . . ., retrato de Filipo Amadi del 1505 . . ., retrato de Adriano Amai cavalier del 1611, uno retrato di cardinale in tella con soaze negre . . ."; Padua, Archivio di Stato, *Archivio Notarile*, b. 4948, fols. 555–87, January 1, 1627. Adriano, who also owned two paintings by Giovanni Bellini, probably had acquired part of the collection of family portraits from his Venetian cousins who were in financial straits.

79. An annotation dated December 20, 1650, tells us: "Questa famiglia hora è estinta di maschi et vivono al secolo in Venezia Faustina quondam Agostino Amadi et in Padova Isabetta quondam Pietro sopradetto vedova del quondam signor Francesco Capodilista da San Georgio." An insert dated 1700 tells us that the Amadi inheritance, including the palazzo at Prato della Valle in Padua, had been assigned to the Dondi dall'Orologio family; *Cathalogus Amati*, fol. 348v. Part of Adriano Amadi's collection of paintings remained with the Veruzzi family; ASVe, *Giudici del Proprio, Mobili*, b. 88, reg. 254, fols. 107v–108, April 22, 1669, dowry inventory of the late Cristina Veruzzi, widow of Adriano Amadi, *cavaliere*. In Venice today, one side of the Campo Manin (formerly Campo San Paternian) still bears the place-name "Soto-portego dei Amai," where there were some houses listed in the *redecima* of 1661 as belonging to Elisabetta di Pietro Amadi, widow of Francesco Capodilista; see Giuseppe Tassini, *Curiosità veneziane* (Venice, 1887; repr., Venice, 1990), p. 16.

THE RESTORATION AND TECHNICAL EXAMINATION OF SAINT JEROME AND A SUPPLICANT

BY ROBERTO BELLUCCI, CECILIA FROSININI, CHIARA ROSSI SCARZANELLA

1. Roberto Bellucci and Cecilia Frosinini, "Piero della Francesca's Process: Panel Painting Technique," in *Painting Techniques: History, Materials and Studio Practice; Contributions to the Dublin Congress, 7–11 September 1998*, ed. Ashok Roy and Perry Smith (London, 1998), pp. 89–93.

2. Giulio Manieri Elia in *Piero della Francesca e le corti italiane*, ed. Carlo Bertelli and Antonio Paolucci, exh. cat., Museo Statale d'Arte Medievale e Moderna, Arezzo (Milan, 2007), pp. 196–99, no. 2.

3. Roberto Bellucci and Cecilia Frosinini, "Ipotesi sul metodo di restituzione dei disegni preparatori di Piero della Francesca: Il caso dei ritratti di Federico da Montefeltro," in *La Pala di San Bernardino di Piero della Francesca: Nuovi studi oltre il restauro*, ed. Emanuela Daffra and Filippo Trevisani, Quaderni di Brera 9 (Florence, 1997), pp. 167–87.

4. Fabio Aramini, Stefano Ridolfi, Fabio Talarico, and Mauro Torre, "Analisi non distruttive e diagnostica per immagini: Fluorescenza ai raggi X, riflettografia infrarossa e in falso colore, luce radente," in *La luce e il mistero: La Madonna di Senigallia nella sua città; il capolavoro di Piero della Francesca dopo il restauro*, ed. Gabriele Barucca, exh. cat., Rocca Roveresca, Senigallia (Ancona, 2011), pp. 131–35, especially p. 134.

5. Roberto Bellucci and Cecilia Frosinini, "La pianificazione dell'opera e il disegno preparatorio nel Polittico della Misericordia," in *Ripensando Piero della Francesca: Il Polittico della Misericordia di Sansepolcro; storia, studi, indagini tecnico-scientifiche*, ed. Mariangela Betti, Cecilia Frosinini, and Paola Refice (Florence, 2010), pp. 189–202, especially p. 198.

6. Giorgio Vasari, *Le vite de' più eccellenti pittori, scultori e architetti: Nelle redazioni del 1550 e 1568*, ed. Rosanna Bettarini and Paola Barocchi, vol. 3 (Florence, 1971), p. 264.

7. Carmen Bambach Cappel, "On '*La testa proportionalmente degradata*': Luca Signorelli, Leonardo, and Piero della Francesca's *De prospectiva pingendi*," in *Florentine Drawing at the Time of Lorenzo the Magnificent: Papers from a Colloquium Held at the Villa Spelman, Florence, 1992*, ed. Elizabeth Cropper, Villa Spelman Colloquia 4 (Bologna, 1994), pp. 17–43.

8. In Longhi's words of 1927, "Gone is the idea of painting as a beautiful mirror with a dogmatic centrality, since the mathematical center of the picture is occupied by the distant appearance of a city constructed by men"; Roberto Longhi, *Piero della Francesca*, new ed. (Florence: Sansoni, 1975), p. 38; On the other hand, Eugenio Battisti, *Piero della Francesca* (1971; rev. ed., Milan, 1992), p. 294, recognized that "the height of the horizon more or less coincides with the height of Saint Jerome's eyes, and thus relates as much to them (being about two thirds of the way up the image, as was advised for such small works) as to those of the onlooker. Maybe the extraordinary power of the saint's gaze depends on this." We may add that Battisti's discourse, though more nuanced as regards the question of spatial setting, corresponds more closely to reality.

9. Antonietta Gallone, "Lo studio analitico dei pigmenti," in *La Pala di San Bernardino*, ed. Daffra and Trevisani (see note 3 above), pp. 257–61 and ills. pp. 254–56, especially p. 255.

10. Aramini, Ridolfi, Talarico, and Torre, "Analisi non distruttive" (see note 4 above), p. 135.

11. Maria Clelia Galassi, "Underdrawing vs. Undermodelling: Form Construction in Tuscan Painting during the First Half of the 15th Century," in *La Peinture et le laboratoire: Procédés, méthodologie, applications*, ed. Roger van Schoute and Hélène Verougstraete, Le Dessin sous-jacent et la technologie dans la peinture, Colloque 13 (Leuven, 2001), pp. 131–41.

12. Bellucci and Frosinini, "Ipotesi sul metodo di restituzione dei disegni preparatori di Piero della Francesca" (see note 3 above), p. 183.

13. The early fourteenth century–presumably–saw the European discovery of silver-yellow (*giallo d'argento*), a substance based on metallic oxides and which with annealing yields an extensive number of yellows; this enabled tonalities on a sheet of glass to be chromatically enriched, and lent color both luminosity and depth. It should be recalled, in this context, by coincidence, that the patron came from Venice, a place of rich and widespread glass production.

14. Peter W. Parshall, "Albrecht Dürer's *St. Jerome in His Study*: A Philological Reference," *Art Bulletin* 53, no. 3 (September 1971), pp. 303–5.

15. See, for example, Michele Bacci, "Immagini e devozione nel tardo Medioevo lucchese: Alcuni riflessioni in margine alla mostra," in *Sumptuosa tabula picta: Pittori a Lucca tra gotico e rinascimento*, ed. by Maria Teresa Filieri, exh. cat., Museo Nazionale di Villa Guinigi, Lucca (Livorno, 1998), pp. 76–97.

ACKNOWLEDGMENTS

The authors would like to thank the following:

Peter Antony, Paola Baldari, James Banker, Michael Battista, Andrea Bayer, Rosanna Binacchi, George Bisacca, Paul Booth, Bruce Campbell, Andrew Caputo, Ciro Castelli, Barbara Cavaliere, Isabella Cecchini, Ottavio Ciappi, Marco Ciatti, Matteo Ceriana, Frank Dabell, Giovanna Damiani, Olivia d'Aponte, Alain Elkann, Robyn Fleming, Michael Gallagher, Babette Hartwieg, Tom Henry, Ling Hu, Jayne Kuchna, Carlo Galliano Lalli, Giancarlo Lanterna, Dorothy Mahon, Renato Miracco, Stefano Piasentini, Evan Read, Anandaroop Roy, Jennifer Russell, Xavier Salomon, Andrea Santacesaria, Alba Scapin, Renata Segre, Linda Sylling, Jane S. Tai, Rosaria Valazzi, Robert Weisberg, Stefan Weppelmann